Setting up a successful photography business

Lisa Pritchard

A&C BLACK • LONDON

First published in Great Britain 2011
A&C Black Publishers,
an imprint of Bloomsbury Publishing Plc
50 Bedford Square
London WC1B 3DP
www.acblack.com

ISBN: 978-1-4081-2577-9

Cover design: Sutchinda Rangsi Thompson
Page design: Susan McIntyre
Project editor: Alison Stace

This book is produced using paper that is made from wood grown in managed, sustainable forests. It is natural, renewable and recyclable. The logging and manufacturing processes conform to the environmental regulations of the country of origin.

Printed and bound in Singapore

Setting up a successful
photography business

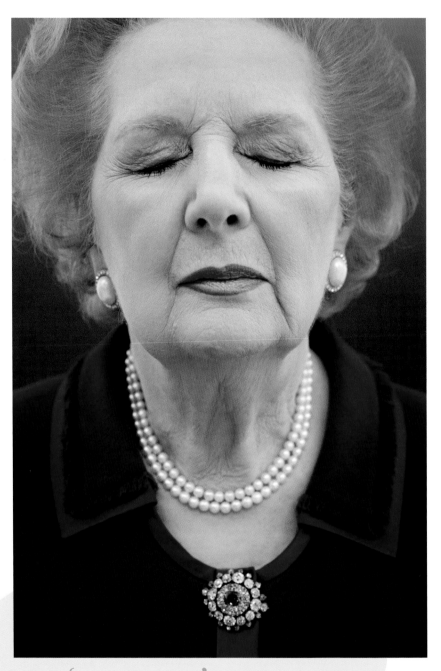

'It's wonderful, I feel blessed.'

HARRY BORDEN ON WHAT IT'S LIKE TO BE A PROFESSIONAL PHOTOGRAPHER.
MARGARET THATCHER © HARRY BORDEN. WWW.HARRYBORDEN.COM

Contents

Acknowledgements

I would like to say a huge and heartfelt thank you to the following contributors, without whose generosity in donating insight, advice and images this book would not have been possible:

Harry Borden, Tom Stoddart, Iain Crockart, Jaap Buitendijk, Colin Davidson, Nick Daly, Julia Boggio, David Slijper, Nick Guttridge, Nick David, Steve Bloom, Igor Emmerich, Sam Stowell, Thomas Ball, Julian Calverley, Laura Pannack, Perou, Nadav Kander, Rankin, Leah Mitchell, Sophie Chapman Andrews, Lucy Webb, Michael Trow, Sara Rumens, Jacqui Wald, Zoe Whishaw, Angie Davey, Georgina Bernard, Stephen Poole, Tom Carson, Conrad Tracy, Tilley Harris, Toby Coulson, Michael Hefferman, Liam Ricketts and Ally Nelson.

Thanks to Alison Stace and all at A&C Black for bearing with me while I finished the book.

Thanks to the team at LPA for their continuous help and support.

And finally I would like to thank my friends and family for their encouragement throughout this whole book-writing process, in particular my husband Adrian Borra for his love, guidance and patience.

Introduction

This book is a no-nonsense, step-by-step guide to setting up a successful photography business. It is aimed at anyone who wants to be a professional photographer – whether you are studying to become one, thinking of a change of career or want to know how to improve your existing photography business.

Setting up a Successful Photography Business is packed with words of wisdom and invaluable advice from leading photographers and commissioners working in all areas of the profession today. It also contains lots of useful checklists, charts and handy business templates. The book is written from the perspective of a photographers' agent – the perfect viewpoint from which to comment honestly on what works and what doesn't, and why some photographers succeed while others fail.

Earning a living taking pictures sounds like a great idea, but it's not just a matter of picking up a camera, shooting away and waiting for the money to roll in. So where do you start?

O What's it really like to be a professional photographer?

O How do you know if you've got what it takes, or even what kind of photographer you should be?

O How do you make the transition into becoming a professional photographer ?

O How do you get your portfolio and website together, market yourself and find clients?

O How do you cost and organise shoots?

O How do you find an agent or a gallery to represent you?

O What about all the business and legal stuff you need to know?

Setting up a Successful Photography Business answers all these questions, plus many more.

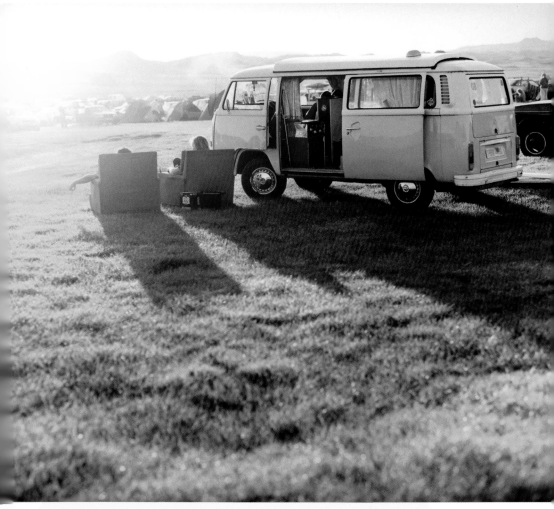

"It's a way of expressing some inner need to be "creative" even if
everyone around you says – and this happens a lot! – "why are
you taking a picture of that?""

NICK DALY. CAMPER VAN. © NICK DALY WWW.NICKDALY.CO.UK

1 So, you want to set up your own photography business?

What's it like being a professional photographer?

See the section on contributors (pp.132–134) for biographies on many of these photographers.

> It's wonderful, I feel blessed. You have to have the right temperament though. You have to be able to cope with long periods of inactivity and being only as good as your last job.

HARRY BORDEN

> My picture editor on a very small local newspaper said on my first day of work 40 years ago that I would have a "champagne lifestyle on a beer salary". He was right!

TOM STODDART

> Most of the time, [it's] brilliant ... I have been to amazing places and countries I would have not travelled to, met incredible people who I would have not met. This is the utopian view, but honestly it's the best job I've ever had.
>
> The best thing about being a photographer is quite simply being paid to do something you love, the problem solving, working with people, the excitement, the new experiences, each day different (mostly). Even if the day is going badly for whatever reason, it's only one day.

IAIN CROCKART

> It's hard to describe, except to say it's a way of life. You never stop looking at life and making pictures in your head – people on the street, kids playing in the park, the sun coming through the trees, or even foggy mornings and street lamps. It's a way of expressing some inner need to be "creative" even if everyone around you says – and this happens a lot! – "Why are you taking a picture of that?"

NICK DALY

'One of the things I love about event photography is that it's outdoor work: photographing magnificent horses piling over five-foot hedges following a pack of hounds or taking pictures of someone over an impressive cross-country jump with rolling countryside behind them. I'd go out of my mind sitting in an office. Of course the downside is you can be stuck out in pouring rain and freezing winds for eight hours at times.

There's also a huge job satisfaction in capturing a memorable moment for someone in a photo that will give them pleasure to look at for possibly years to come. Event work, especially equestrian, can mean long and sometimes gruelling days, but if you work hard you can earn well. You're always the first on the show ground or at the venue and the last to leave. Lunch breaks? Rarely. Cup of tea? Not likely. Sore feet? Always. It can be physically full-on work, especially when you're running round with three kilos of Nikon's best around your neck covering several different showing rings and climbing under boundary ropes and dodging horses.'

COLIN DAVIDSON

'Some of the things I really enjoy and hate about my "work":

I don't really see it as work; I look forward to every commission and opportunity to be paid to make more pictures.

I used to think flying round the world was cool. I like to see the world, but getting there is just long-distance commuting.

I like at times and hate at times being self-employed: I decide what I do, how and when. I don't have to do anything; I'm the boss. Being a self-centred egotist, the omni-powerful role suits me just fine.

I like eating local food in far-off places. I like hanging out with talented, creative people. I don't like meeting my heroes so much: it's often disappointing. But sometimes I meet people I wasn't expecting to enjoy, who share a little.

I get paid well to enjoy myself. Photography is my enabler.'

PEROU

'People think it's glamorous mixing with the stars, but while it is interesting getting friendly with some famous people, at the end of the day we are all there to do a job. I am a department of just one person: me. I have to be on the ball all the time, ensuring that I'm not in anyone's way or making a noise. It's hard work. You have to be on set early and between shooting you have to edit the pictures you've taken. You may then have the big producers and art directors over from the US, or suchlike, watching as you shoot what will likely be the poster for the movie.

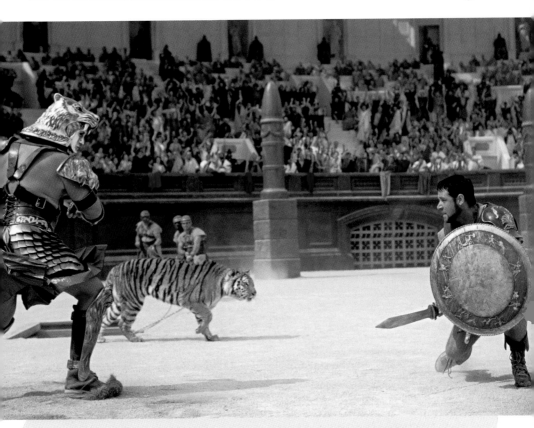

'People think it's glamorous mixing with the stars, but while it is interesting getting friendly with some famous people, at the end of the day we are all there to do a job.'

JAAP BUITENDIJK. GLADIATOR. © JAAP BUITENJICK WWW.JAAPPHOTO.COM

Sometimes you can be left hanging on for hours waiting for the actor to become free, which is frustrating. But there is no point getting stroppy – I work hard at remaining cool and calm even under very testing circumstances.

I often work a six-day week, and often do night shoots. I hardly see my family when I am working and I can be away for months at a time. Then you might have six months off and start to worry that you'll never work again. Then the phone will ring with a request for my book and sometimes there can be three job offers on the table at once. It is very difficult to be in control of you own time – planning holidays is pretty challenging.'

JAAP BUITENDIJK

A week in the life of ...

As the title suggests, this book is about setting up a successful photography business. 'But I don't want to set up a business,' I hear you cry. 'I just want to be a professional photographer.' The crucial thing to accept when you start out as a professional photographer is that you are setting up a business. And, as with most businesses, there are several different 'departments' that you will be responsible for – often on a weekly basis.

Maybe one day you'll be able to delegate some of these responsibilities and concentrate more of your time on taking the pictures. Most photographers however, especially those just starting out, find their time is generally divided between several diverse tasks.

Department	Responsibilities
Production	Developing and creating the product: building your portfolio, planning and preparing for shoots, shooting and editing the images.
Marketing and Sales	Planning the marketing, promoting the product, generating the business. Pricing the work and negotiating with customers.
Account Management	Overseeing the logistics of a shoot.
Customer Services/Reception	Answering customer enquiries and dealing with requests.
PR	Networking and self-publicity.
Accounts	Invoicing and credit control.
Administration	Office supplies, filing, administration systems.
Human Resources	Hiring and training additional staff.
Technical Support and Development	Maintaining and updating all photographic equipment, computer hardware and software. Keeping up to date with changes in technology.
Legal	Dealing with business contracts and other legal issues.

Professional photographers don't just take pictures. In fact, most of them spend a comparatively small amount of time behind the camera and a surprisingly large amount of time trying to create the opportunity to take those pictures in the first place. Whether you're a fashion photographer or a war photographer, one day you might be on an intense and challenging shoot, the next you could be updating your website, doing your tax return or repeatedly hitting the 'Get Mail' button wondering why no one's replying to your messages. The joys of being freelance!

Julia Boggio runs a successful wedding and portrait photography business in London – Julia Boggio Studios.

'There is no such thing as a typical week in my life. The only consistent occurrence is the Monday morning traffic meeting, where I get together with our studio manager, head of post-production and managing director to go over all the jobs that are going through the studio, to make sure we're hitting our deadlines. Other than that, I could be photographing babies on Tuesday, networking on Wednesday, shooting boudoir on Thursday, taking a brief for a commercial shoot on Friday and shooting a wedding on Saturday. The next week, it will be completely different.

When I started Julia Boggio Photography, I did all the jobs of running the company. Now I have someone who does most of the retouching and post-production (she was my first big overhead at the end of year two); a studio manager who books shoots and appointments, manages our projects and keeps me from getting bothered by sales calls; and then there is my husband, James, who joined me in the company two years ago. He is the managing director and takes care of the financials, IT, HR and sales, and we share the marketing.

The nice thing about this set-up is that I am left to be the creative director of the company. My current jobs include coming up with new ideas, public relations and networking, checking our output to make sure we maintain our quality standards, training new photographic staff and, of course, shooting. A lot of shooting.'

Have you got what it takes?

I have seen many talented photographers fail where their less-talented competitors have succeeded. Why? Because they lack certain other qualities that are necessary for success.

The constitution to be self-employed

Most professional photographers are freelance, although staff jobs do exist. The demands and unpredictability of being self-employed do not suit everyone. This isn't going to be a nine-to-five job with a secure salary, holiday pay and a pension plan.

Drive and passion

It's a very competitive industry because it's such an attractive one, so you'll need to be completely driven and passionate about wanting to be a professional photographer on both a creative and a business level. It's up to you to find your own clients. Are you willing to invest the required time, money and energy? Are you willing to make compromises and sacrifices?

Patience and a strong work ethic

This isn't the kind of industry where you can make a fast buck when you first start out. I know plenty of photographers who enjoy a very comfortable lifestyle once they have become established in their careers, but money was rarely their number one motivator. To be successful will require a lot of patience and hard work.

Thick skin

You need to sell yourself and your photography, which means dealing with a few hard knocks on the way and being able to take criticism on the chin. Most feedback is constructive, so do listen to others.

A mind for business

You can be the greatest photographer around, but if you don't treat photography as a business, you won't get far. It's important to develop your business skills as well your photography skills: even if one day you might have an agent, a producer, a PA, a publicist and four assistants, you will still be ultimately responsible.

A professional attitude

Aside from the obvious no-nos like turning up late for a client meeting or shouting and swearing at your assistant on a shoot, it's important to maintain an efficient and business-like approach. You are unlikely to build up lasting client relationships if, for example, you go way over budget on a shoot, double-book and have to cancel, overlook getting a location permit or even just respond to an enquiry too late.

Entrepreneurial flair

I've witnessed a certain entrepreneurial flair in many successful photographers. They make their own opportunities and aren't afraid to take risks. Their unflinching self-motivation seems to drive them to succeed no matter what. They are doers, they make things happen and they always bounce back after a set-back.

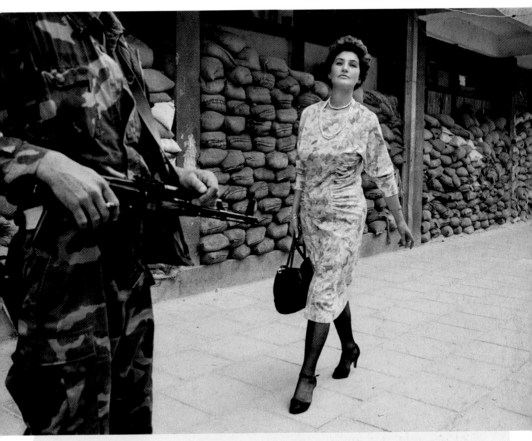

'My picture editor on a very small local newspaper said on my first day of work 40 years ago that I would have a "champagne lifestyle on a beer salary". He was right!'

TOM STODDART. DOBRINJA MELIHA VARESHANOVIC WALKS PROUDLY AND DEFIANTLY TO WORK DURING THE SIEGE OF SARAJEVO. © TOM STODDART/REPORTAGE BY GETTY IMAGES. WWW.TOMSTODDART.COM

Confidence

You need to be confident enough to believe in yourself but not so egotistical as to make enemies.

A knack for publicity

It helps a lot if you naturally want to shout about your photography. But make sure you have something worth shouting about.

The likeability factor

Photography is mostly a people industry, and the main reason clients come back for more or recommend photographers to others is because working with them was an enjoyable experience.

Good communication skills

In most areas of photography it's important to be able to communicate well. Whether presenting your work in the right way to the right audience to gain commissions, listening to a client's needs at a briefing or getting the best out of your crew on a shoot, the ability to interact well with others will be a distinct advantage.

Being realistic

Being a professional photographer is not always a bed of roses, so go into the profession with your eyes open. While many photographers earn a very good living doing what they love, some earn a very good living but don't get to shoot what they love all the time. That's just how it is in most professions.

A memorable or 'signature' style

In such a competitive industry you need to have something that people will remember you by. (See pp.28-33, How to find your niche).

Talent

It does of course help to be both a creatively and technically talented photographer too.

Being a professional photographer can sometimes be a contradiction in terms. You need to be a sensitive artist and a thick-skinned sales person; you need to strike that fine balance between being creative and passionate, yet ambitious and business-minded. Yes, you need to be able to take great pictures but that alone is not enough to succeed in this industry.

2 Who buys photography?

Look around you, chances are you are probably surrounded by imagery: a poster in the street, in the newspaper you are reading, the packaging of the food you're eating. But how did these images get here? Who buys photography?

Communications agencies

Companies such as Procter & Gamble and Virgin employ the services of communications agencies to devise ways to promote their products and services. Communications agencies include, among others, companies specialising in advertising, design, marketing, PR, branding, digital and direct marketing.

Traditionally advertising agencies created press and poster campaigns and design agencies were responsible for printed materials such as brochures and packaging. However, the dividing line between the different types of agencies is blurred these days, with lots of communications agencies offering what's known as integrated communications: a range of communication disciplines crossing either side of the old boundaries. For example, a design agency might create an outdoor poster campaign and an advertising agency might create a website for their respective clients.

Communications agencies often use photography to illustrate and strengthen the marketing message, and photography used in this context is also known as commercial photography. The agencies either commission the appropriate photographer to work to a specific brief or source existing or stock photography from a photo library.

Larger advertising agencies have art-buying departments. The art buyers find photographers for the creative teams and deal with the whole shoot process, from estimating costs to the delivery of final images. Creative teams are made up of a copywriter and an art director, who conceive the campaigns aimed at their client's target audience. Creative directors oversee the creative teams and are involved in the day-to-day running of the creative department.

Photographers should aim to see art buyers, art directors and creative directors (in advertising agencies), but the best person to contact can vary. Buyers of photography can go by different names depending on the structure of the agency: for example, a creative services manager might take

the place of an art buyer or project manager, so it is always best to ask who is responsible for commissioning photography. Within some design agencies, the designers themselves or sometimes their project managers source photography. Art directors and designers work in close collaboration with the photographer throughout the shoot process and usually attend the shoot. Creative directors oversee and approve the photography, while art buyers and project managers deal with logistics and budget.

The type of photography used varies enormously from project to project, although certain approaches suit certain products and services: food photography for a supermarket promotion or food packaging, images of people for healthcare marketing or corporate communications. You can't always second-guess what photography will be required – still-life photography might be used for a car advert or underwater photography for a beauty product.

Aspiring commercial photographers often ask me what sort of photography is being commissioned at the moment. Well, the evidence is there for everyone to see on the hundreds of advertising messages we see every day. Here are some other ways to find out more about the use of photography within the commercial industry:

O Read the trade press and blogs: *Campaign, Design Week, Creative Review, Marketing Week, PR Week.*

O Check out the winning entries in commercial photography competitions, such as the International Photography awards (also known as the Lucie Awards), the AOP Awards, the *Campaign* Photo Awards and the D&AD Awards.

O Take a look at the websites of communications agencies, which will reveal more about the type of photography they buy: one design agency might commission lots of corporate portraits whereas another might commission mostly portraits of bands for album covers.

O The websites of successful commercial photographers are another good indication of photography that is actually being commissioned.

O You can also catch up on the current topics of interest in commercial photography by joining associations, looking at their websites and partaking in online forums, such as that of the Association of Photographers.

information about UK magazines, and there are several associations and forums for editorial photographers where more information on the market can be sought, including those of the National Union of Journalists (www.nuj.org.uk), Editorial Photographers United Kingdom and Ireland (www.epuk.org) and British Press Photographers Association (www.thebppa.com).

Book publishers

Like publishers of magazines, book publishers use editorial photography to illustrate a topic or sometimes to accompany a narrative. Thousands of new titles are published every year and just as books vary enormously in content, from education text books to romantic fiction, so does the nature of the photography used. You can identify these different types of photography by browsing in bookshops and libraries, as well as by looking at websites such as www.amazon.co.uk and on individual book publisher's websites.

Paper product manufacturers

Companies that manufacture paper products such as greetings cards, postcards, calendars and posters buy a variety of photography – anything from a stunning landscape to a basket of cute kittens. The manufacturers commission photography and buy existing images from photo libraries. You can research this area further by having a look at what is on sale in the shops and online.

Film and TV production and distribution companies

Film and TV production and distribution companies commission photography for publicity purposes. The photographer works on set for sometimes weeks at a time (in the case of a film) and is known as a stills photographer.

The general public

And finally, members of the general public also buy photography. Areas include school and family portraits, as well as local social and sports events such as a horse show or a fair, at which photographers are hired as official event photographers. The consumer can then view, select and buy prints of themselves from the photographer's website.

The biggest area is wedding photography. Aside from looking in wedding magazines and on wedding photographers' websites to see popular styles of wedding photography, more information can be found on association websites such as those of the Society of Wedding and Portrait Photographers (www.swpp.co.uk)

and the Master Photographers Association (www.thempa.com).

Members of the general public also buy photography as art. Buyers might be private collectors investing in a limited-edition print or just your average person buying more affordable, accessible pieces of art they enjoy looking at. Fine art photography is about the photographer's pure creative vision: the images might have a meaning, an idea or a message, they might express a concept or make a statement. Subject matter can include pretty much anything from an evocative seascape to a stunning portrait to an intriguing empty space.

Examples of the best of fine art photography can be seen in top galleries such as the Michael Hoppen Gallery in London (michaelhoppengallery. com), while you can see work by young photographers at specialist online galleries such as Degree Art (www.degreeart.com) and Eyestorm (www. eyestorm.com).

Some general points to consider

It's important to understand who buys photography to understand how you can earn a living from being a photographer. It is also important to understand what sort of photography the different markets use to see where you fit in. It may be that your work lends itself naturally to one area, or perhaps at this stage some development and refinement is necessary to make your work of interest to the buyers.

It is up to you to research the markets you are interested in before approaching them with your work, not only to check out what type of photography they would be interested in but to educate yourself about the industry you intend to get work from – you wouldn't go for a job interview without checking the company website or reading something about the industry first. Read the trade journals and blogs, keep up with evolving trends, become an expert. Then you can have an informed opinion and be taken seriously. A lot of photographers at the beginning of their careers don't appreciate the importance of this. For example, it's advisable for an aspiring advertising photographer to read *Campaign* or *Creative Review*, as they are the leading trade magazines for the advertising industry. Likewise, it's important to know what imagery will appeal to the readership of a particular publication – a magazine has usually spent years identifying its target audience so it can use appropriate imagery.

In their training, sales people are told first to identify a client's needs before attempting to sell them a service or product. Before you can progress with your career, it is important to identify a market that can truly benefit from your photography. This will also prevent you from wasting everyone's time, including your own. If you feel you have found your niche, it's just a

matter of confirming there is a market for your work and that your idea of what is marketable is the same as the buyers'. Is there much call for highly stylised slapstick-style photography in advertising right now or is a more natural style *de rigueur*? Do brides mostly want black-and-white reportage-style shots in their wedding album or fun, uplifting images?

If you are still developing your photography and are yet to find your niche, the next chapter should provide inspiration.

JULIA BOGGIO. MEMBERS OF THE GENERAL PUBLIC ALSO BUY PHOTOGRAPHY. THE BIGGEST AREA IS WEDDING PHOTOGRAPHY. © JULIA BOGGIO WWW.JULIABOGGIOSTUDIOS.COM

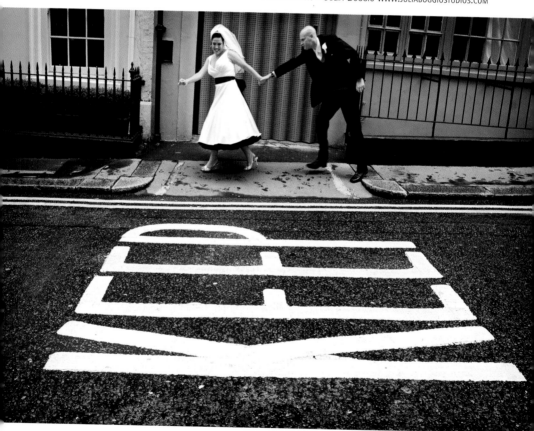

3 What sort of photographer are you?

As a professional photographer, you'll be regularly asked the question 'What sort of photographer are you?' There are many labels you can give yourself, from fashion to food photographer, commercial to corporate photographer, still-life to stock photographer. Which label is the right one for you?

Do you need to specialise?

Most professional photographers do specialise, at least in style and often in subject matter, but not necessarily in their client area or market. Many photographers, particularly in the commercial and fine art markets as well as in the editorial world, develop what's known as a 'signature style'. A still-life photographer who also shoots portraits might be identifiable as the same photographer if, for example, the lighting technique or the colour palette remain consistent. In certain areas – event or wildlife photography – for example, the subject matter is more identifiable than the photographer's style. Having said that, the event photographer may well specialise in one market area.

I believe it's important to find a niche. How else will potential clients identify you? Your niche could manifest itself in any or all of the following:

- Subject matter
- Style
- Technique or treatment
- Market /client area

Most of the commissioners of photography that I speak to think it's important to be able to identify a photographer by the style or subject matter of their work.

Previously an advertising art buyer and a photographer's agent, Lucy Webb is now creative services manager at Landor, one of the UK's leading branding agencies.

'I think it's important for a photographer to have a niche. A consistent folio stands out and is more than likely to be remembered. It's also the USP of most

photographers so you should stay true to it. Someone who has a folio full of varying styles, colour palettes, lighting styles etc, can seem unsure about what they want to be in the photography industry.'

I'm not disputing that there aren't working photographers who don't particularly specialise, but you will find that the majority of successful photographers do. Let's look at some of the benefits:

○ *There is more chance of being remembered when a suitable job comes up.* Whether they are an art buyer at an advertising agency or a bride-to-be, most commissioners of photography are very busy people – you need to make their decision as easy as possible. Name a successful photographer or one whose work you admire: chances are you remember their work because they have found their niche and are identifiable because of a specific subject matter or style.

○ *If you choose one area that you genuinely are interested in and enjoy, you will naturally take better pictures and be more motivated.* If you're not interested in the world of celebrities and tabloid rumours, you're soon going to loose your enthusiasm for getting the million dollar shot of some footballer's wife having a bad hair day.

○ *There is more likelihood of your becoming an expert in one area if you spend more time on this one area.* I remember a still-life photographer I used to represent making a spectacularly bad job of directing some toddlers on a shoot for which he was commissioned. And I also recall a specialist children's photographer having a much more successful day, bringing along with her a plethora of games and toys and taking a four-year-old's attention span into consideration.

○ *It will make a potential client feel confident that they are making the right decision, thereby giving you a better chance of getting the job.* Let's imagine that one photographer has lots of images in his book of models interacting in an energetic, positive way. The client, who needs this look for a catalogue shoot, once chose a photographer who wasn't very good at getting the best out of the models. He can be more confident that this photographer will do a better job.

○ *Having a niche generally gives you focus and direction. You can put all your efforts into one area and not be distracted.* Be careful not to over-specialise, however, or to restrict yourself to only a very specific style and subject matter – very moody country landscapes, for examples. You could add some moody cityscapes with perhaps some people in them to increase the amount of commissions for which you would be suitable.

The options

These are some of the most popular specialist subject areas or genres of photography: aerial, animals, architecture and interiors, beauty, cars, celebrity, children, corporate, equestrian, events, fashion, food, forensic, glamour, industrial, landscape, lifestyle, medical, music, news, paparazzi, photojournalism/documentary/reportage, people, performing arts, pets, portraits – studio, and location, product, school, science/nature, social, sports, still-life, travel, underwater, wedding, wildlife.

You may find that you already have a natural leaning towards one or more of these areas, and can work on developing your signature style as you evolve as a photographer. As you discovered in the last chapter, there are a number of different industries that buy photography and many ways in which photography can be used, so it is not always necessary to specialise in a market or client area. In addition, few of these markets are big enough to sustain all the photographers that seek work within them.

Even the most successful and well-known photographers, although they have found a niche, shoot for a range of markets: a documentary photographer might shoot news stories and weddings, a portrait photographer could shoot a portrait for a newspaper (editorial) or for a cereal packet (commercial), a landscape photographer might sell his or her work through a fine-art gallery as well as a stock picture library, a fashion photographer might get commissioned by a glossy magazine and also by a mail-order catalogue, a sports photographer might sell stock through a specialist sports photolibrary and also be regularly commissioned for a sports magazine.

There are always going to be exceptions to the rule, however, and some photographers only work for one market: a portrait photographer might only work for the editorial market and by choice or default, a lifestyle photographer might only work for design and branding agencies, for example.

How to find your niche

Deciding what area of photography to specialise in is usually a natural process rather than an active choice. Ask yourself the following questions:

O Which photographers inspire you and how do they earn a living from their photography?

O What sort of images do you enjoy shooting?

O What sort of photography are you good at?

O What are you knowledgeable about or experienced in? Maybe you studied architecture at college – that would come in very handy if you wanted to be an architectural photographer.

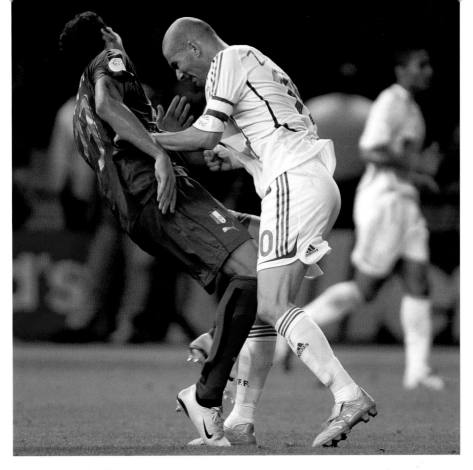

ITALY'S MARCO MATERAZZI FALLS ON THE PITCH AFTER BEING HEAD-BUTTED BY FRANCE'S ZINEDINE ZIDANE DURING THE 2006 WORLD CUP FINAL IN BERLIN. © REUTERS/ACTION IMAGES

O Where would you like to see your work? On billboards, in coffee-table books or fine-art galleries?

O What are your hobbies? It may be as simple as a love for skydiving or interior design.

O Will your personality suit the lifestyle your chosen type of photography might dictate? If you don't like spending too much time away from home, location or travel photography probably isn't for you. If you lack confidence when you meet strangers or haven't got the best communication skills, you might not be cut out to be a portrait photographer. Consider what it might be like on a shoot and if you would be comfortable doing what you needed to do or if it would be your idea of hell. I usually find a photographer's personality comes across very strongly in his or her work and that is how their signature style evolves – perhaps they have a dry sense of humour, are deep and thoughtful or very accurate and considered in their mannerisms.

Whatever area you decide to specialise in, you need to be sure there is a potential market for your images. You need to be certain that you are offering a viable and useful commodity that people will pay for. You can do this by exploring what sort of photography is actually used in the different markets discussed in the previous chapter.

I asked some successful photographers about 'finding their niche'.

'Like most people I learnt something by just being interested and picking up a camera. As a teenager I would read every book and magazine I could find. I had no idea who any of the photographers were – but I remember images that must have permeated from the Magnum photographers of the mid-twentieth century. I would go around my home town in the north of England with a basic 35mm SLR taking pictures of homeless people or trees or anything I could try to make into a photograph. I would drop the film at my local chemist and wonder why the images never matched up to the photographs that I had seen.

By my mid twenties, I had become exposed to underground fashion magazines in London and seen work in museums from the ICA to the National Portrait Gallery, and decided that this is what I would do.

I actually started shooting portraits, but realised they were bad copies of a photographer that I worked for. My move to beauty was at first a way of getting away from his portrait style. In fashion, I wanted to make something both beautiful but also as real as I could. I wanted to feel that there was some humanity in the model, that there is an intelligence that can be expressed in a way that felt natural and real. I hated (and still do) the over-dramatic posing and fantasy of much fashion photography. Glamour has been a big trend since the end of the 1990s but my heart has always been in finding something that the model has that is about her rather than just projecting my fantasy on to her. This is why I also love shooting men. There is less pressure in men's fashion to build a fake persona using hair and make-up and fantasy fashion ideas.'

David Slijper

'After moving to the UK from Spain I got a place in Bath to do a degree in graphic design, as I was also interested in typography and printing processes. Initially I got work from college friends so I guess that connection and appreciation for the world of graphic design has always stayed with me.'

Igor Emmerich

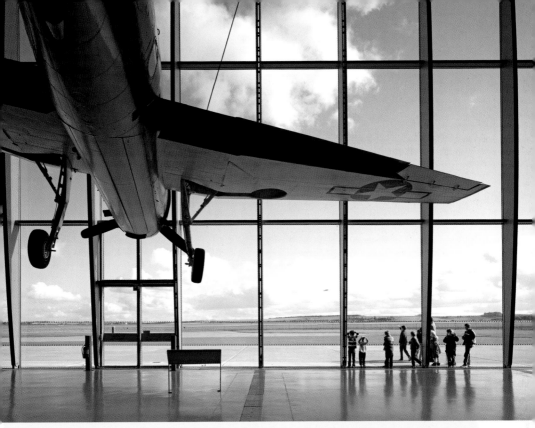

'After graduation I rented a desk space in an architect's studio; I had grown up in a family of architects and felt comfortable working there.'

NICK GUTTRIDGE. AMERICAN AIR MUSEUM DUXFORD – FOSTER & PARTNERS.

© NICK GUTTRIDGE, WWW.NICKGUTTRIDGE.COM

'While studying product design at art school I realised how integral the camera was to the design process. After graduation I rented a desk space in an architect's studio; I had grown up in a family of architects and felt comfortable working there.

I was lucky enough to assist some of the best architectural and interiors photographers and was motivated by my fascination for large-format photography. To begin with I was more interested in using the camera to be part of the architectural scene, getting published and seeing the images in exhibitions. My technical and artistic background helped me create images with a sensitivity to proportion, colour, texture and light.

My niche is still architecture and interiors and I have had some interesting commissions from design and advertising agencies who need this with an added human element too.'

NICK GUTTRIDGE

"My style just progressed. I always liked to photograph people. I don't like to direct too much, so I started developing a natural style. Talking to people is fine, just being interested is usually enough."

NICK DAVID

"I don't like to direct too much so I started developing a natural style."

NICK DAVID. COMMISSION FOR THE DEPARTMENT OF COMMUNITIES AND LOCAL GOVERNMENT. © NICK DAVID. WWW.NICKDAVID.CO.UK

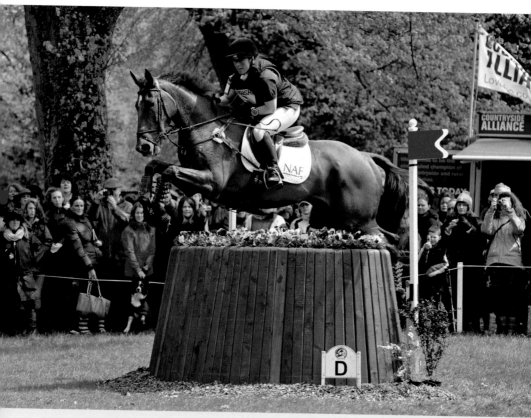

‘I made the move into event photography after meeting my wife Vanessa, a keen horse rider. She produced a bag of old prints of her jumping over logs, tyres and show jumps and told me they cost around £10 each. Two things struck me: one was that the quality of most of the shots was pretty poor, average at best. And secondly I reckoned I could do that – given half a chance.’

COLIN DAVIDSON. CROSS-COUNTRY ACTION AT THE WORLD FAMOUS BADMINTON HORSE TRIALS © COLIN DAVIDSON/ MUDSPORTS EVENT PHOTOGRAPHY. WWW.MUDSPORTS.CO.UK

Eventually I was encouraged to set up my own business by a few of the key clients, so at the age of 24, and after taking on a rather scary bank loan, I opened the doors to my first studio. I'd shoot anything that came along, just to pay the bills, and things remained that way for many years.

I eventually decided I'd had enough of running a studio. It was no longer about my photography, but about paying bills and meeting overheads. I longed for some sort of freedom and relief. I went on to become more location-based, hiring studios as needed. I now work for a range of commercial clients, from high-end performance car manufacturers to Europe's largest carrot grower. I also sell my images through a stock library and as limited edition prints.’

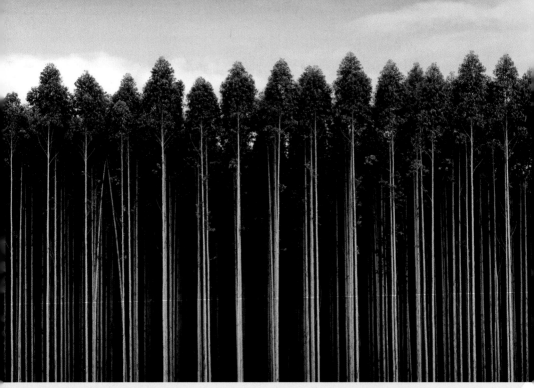

IGOR EMMERICH

'I started by assisting photographers in Spain after finishing my A-levels in Madrid. Once Spain joined the EEC I moved to the UK and got a place in Bath to do a degree in graphic design, as I was also interested in typography and printing processes. While I was at college I also assisted photographers during the summer and Christmas breaks.

As with other competitive careers, it was a mixture of sweat and luck. I targeted magazines and Sunday newspapers, getting commissions with the *Observer*, *Financial Times* and *19 Magazine*. I also got work through college friends and the companies they started working for. And, last but not least, word of mouth.'

'I won a competition that gave me work experience on a TV soap, taking photos for the production team. One of the producers on that soap went on to work on a small film and asked for my services and so it carried on.'

JAAP BUITENDIJK

"I studied documentary photography at Newport in Wales, which is a great course. At the end of the course I won a competition that gave me work experience on a TV soap, taking photos for the production team. One of the producers on that soap went on to work on a small film and asked for my services and so it carried on. Each time I worked on a film, someone would recommend me to their next project and gradually the projects began to get bigger and bigger and my skills as a unit stills photographer grew."

JULIA BOGGIO

"I've been a wedding photographer for seven years, five years of that full time. In that period, I have grown Julia Boggio Photography to be one of the most well-respected and sought-after wedding photography companies in the UK. Before photography, I worked as a copywriter in the advertising industry, but wasn't happy in my job. A six-month sabbatical to South America in 2000 introduced me to the wonderful world of photography. Upon returning to the UK, I enrolled on a two-year course that met on weekends to pursue my passion. When I finished, I bought a digital camera and a friend asked me to shoot her wedding. The rest, as they say, is history.

How did I get started and grow my business? A mixture of careful business planning, shrewd marketing and a fun, quirky style helped to set me apart from everyone else.

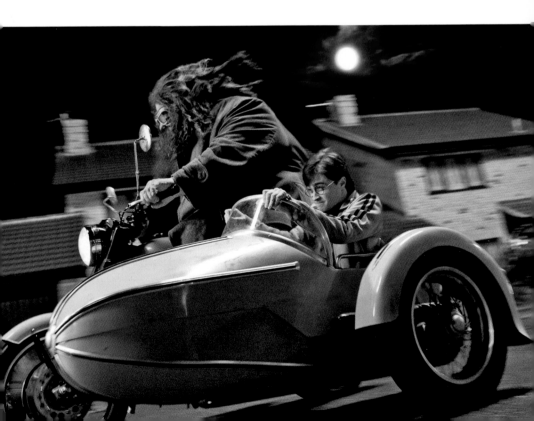

Since I started the company, and also with the advent of the digital age, I have watched a lot of newcomers enter the wedding photography market. Some make it; many don't. The first thing to do is to figure out if it's really for you. You don't want to quit your job and throw yourself into setting up a business, only to find that you'd rather claw your own eyeballs out than shoot a wedding. To avoid this, find a reputable photographer near you who is willing to take you on as an assistant. Top wedding photographers do get an abundant number of this sort of request, so you need to stand out from the crowd. The best unsolicited pitch I ever received from someone who wanted to assist me was a nicely designed photobook that she sent to me in the post with a well-written, grammatically correct cover letter. In the book she showed me some samples of her work and made a case for why I should want to work with her.

You should assist for at least a year, not just to see if you like the industry, but also to see how the business is run. Once you decide that it's definitely something you'd like to pursue, you need to think practically. It will take at least a year for you to start bringing in some money.

Iain Crockart

'I had spent 15 years working as a graphic designer before deciding to become a professional photographer. The decision was not a eureka moment, I had planned the change as I was by this time a joint managing partner as well as a creative director. While still working [as a graphic designer] I practised and practised with my Leica M6, then I bought some great medium-format kit – a Contax 645 – and it seemed to me at the time a way of escaping my very busy and time-consuming day job. It was so beautifully simple: Look. See. Click.

I loved photography, always had. I loved taking pictures, starting as a 14-year-old boy with my father's Olympus OM-1. I found that looking through a viewfinder not only felt like the most natural thing in the world but it also made me look more closely.

When I became a professional photographer I was lucky enough to work with two great assistants. I was very honest when we met: I knew what I wanted to shoot, but technically I was crawling out of the primordial photographic soup. I learned so much in that seven-day shoot. I still work with one of the assistants to this day.

The change in career had another aspect I was not expecting: the joy of learning.'

David Slijper

'I had an academic education – economics at the London School of Economics – and never realised that you could actually be a photographer for a living. By my mid-twenties I had been exposed to underground fashion magazines in London and had seen work in museums and galleries, and I decided that this is what I would do.

'The decision was not a eureka moment, I had planned the change as I was by this time, a shareholder, joint managing partner as well as a creative director.'

IAIN CROCKART. PUDDLE. © IAIN CROCKART. WWW.IAINCROCKART.COM

Thinking I'd need a portfolio to become a photographer, I began walking the streets like Henri Cartier-Bresson. I built a darkroom in my bathroom and learned to print. I realised that my pictures of friends were better than any documentary work that I could do and soon I had a basic portfolio of portraits. At this point I still had no idea how to become a working photographer. My next realisation was when I saw a talk at the Association of Photographers that suggested becoming an assistant was a good way of learning how the business worked. For the next year I called every photographer from every magazine that I could find, and slowly got the odd job helping out, usually for no money. I was a terrible assistant at first. Considering what I need my assistants to know today, I knew nothing at all.

After a few years scraping together enough to survive, I started working more regularly with better and better photographers, understanding lighting and equipment, often developing film, making contacts and even printing for them. Next came testing: I would experiment in Alastair Thain's (the photographer I assisted at the time) darkroom at weekends.

I began mostly shooting beauty because there were no clothes, but I loved lighting, so it worked. One of the pictures that I shot in those days has since been published in *i-D* magazine (for a Prada skincare story) and *Harper's Bazaar*, and has just

recently been sold to a new European beauty line. I always thought the work was not polished enough and so no good. Not true. In fact, the raw energy and lack of sophistication that you have as a beginner can be a great asset.

My first real commissions were for beauty. I shot for the Sunday supplements, doing pages for the *Observer* magazine, *The Times* and the *Independent*. Eventually a meeting at *i-D* magazine led to regular pages and fashion stories for them. My first big break came when I got a call from Camilla Lowther, a major London fashion photographers' agent. A meeting with her, and I was now represented by someone who had some of the big names in fashion.

My next break came when I was asked by *The Face* magazine to go to LA to shoot a new actor who was in a new movie called *The Lord of the Rings*. My cover of Elijah Woods led to more *Face* covers, of Justin Timberlake and Orlando Bloom, and an *Arena* cover of Matt Damon. I loved *The Face* for its creativity and freedom, and for having some of the best photographers. Since then, I have shot editorials for UK, French, Italian and American *Vogue*, as well as countless others. I have advertising campaigns for Jimmy Choo, YSL, Sergio Rossi and Ermengildo Zegna, and beauty campaigns for Rimmel, L'Oréal and Olay.

The truth is making the transition to becoming a professional photographer is rarely a leap, but more of a slow and gradual creep. One thing's for sure: you won't finish studying or assisting on the Friday and start your career as a fully-fledged photographer on the Monday.

Some photographers never make a full transition, by choice or necessity supplementing their income in a related field. I could give hundreds of examples of professional photographers who all have their own unique take on the job title: I know photographers who are also retouchers or location scouts, photographers who also run workshops and write books. I know a glamour photographer who also owns a bikini shop in Ibiza. I also know many photographers who concentrate solely on shooting, and on running their photography businesses.

Photography is an extremely competitive industry, but don't let that put you off. If you work hard at gaining experience and knowledge, are passionate, committed, talented and focused, there's no reason why you shouldn't be a great success.

In the early days of your career learn and experience as much as you can about the industry. Focus on deciding what sort of photography you want to specialise in, and begin to get an understanding of how the market works. Build your contacts and confidence and develop a body of strong and consistent personal work.

If all the basics are in place, now's the time to start building your business: you need a concrete plan of attack. How, exactly, are you going to make a living by taking pictures? The next chapters tell you how.

'I had an academic education – economics at the London School of Economics – and never realised that you could actually be a photographer for a living.'

DAVID SLIJPER. *VOGUE*, CHINA 2011. © DAVID SLIJPER. WWW.DAVIDSLIJPER.COM

6 Business basics

Being a professional photographer equates to running a small business. As with any business, there are ways of operating, managing and protecting it professionally.

A business plan

If you ever read anything about how to start up a business, you will be advised to prepare a business plan. A successful business isn't something that happens overnight and you need to set yourself some clear objectives.

Now, you may be thinking this isn't necessary: you just want to be a freelance creative, not a business entrepreneur. All the business plans you've ever seen include irrelevant stuff like the 'mission statement' and the 'management team', and ask you to *guess* how much money you're going to make. But as we discovered in Chapter 1, being a professional photographer is very much about operating a business.

A business plan forces you to ask yourself some key questions. It will clear your head, get you focused and help you spot any weak areas. A plan allows you to set realistic targets and monitor your progress. You'll also need a business plan if you ever need to raise finance. Here's a simplified version of the traditional business plan that's relevant to photographers.

O *The mission statement*
A summary of your photography business.

O *The product*
Your photography niche and the services you offer.

O *The market*
Who will buy your photography?

O *The management team*
The skills and experience you have that qualify you for a career in the photography industry.

O *The financial plan*
The money bit: how will you afford to set yourself up and survive as

a photographer in the first few years? What are your short- and long-term profit and loss forecasts?

○ *Operations management*
 Consider the structure of your business and other business requirements.

○ *Sales and marketing*
 How do you propose to market yourself and get clients? Prepare a marketing plan (see p.83).

Financial planning

You need to think about how you are going to make it work financially – how you can afford to get up and running and stay up and running. There is rarely a guaranteed monthly income when you are a professional photographer.

Start-up costs

There are however two bits of good news on start-up costs. Firstly, as the transition into becoming a full-time photographer is a very gradual one for most, it's likely you will already have most of the basics required to run a photography business in place long before your official 'day one'. Many start by assisting or work at another photography-related job, pick up a few of their own clients and then realise one day they can afford to focus on being a photographer in their own right. They usually have a camera of their own, a mobile phone and a website at the very least.

Secondly, even if you are starting from scratch and have by-passed the apprenticeship period, start-up costs should be fairly minimal. It is not usually necessary to find premises, buy all your equipment or hire full-time staff when you first start out.

Start-up checklist:

• Mobile phone
• Office equipment: computer and printer
• Photographic equipment: camera, digital technology
• Basic marketing tools (see Chapter 7)
• Insurance
• Legal and other professional fees
• Enough money set aside or an alternative form of income to live on and run your business for the time it takes to really get up and running.

There's a US term, bootstrapping, which means starting up a business with little or no money. Google was apparently founded on credit cards, Microsoft was started in a garage. A former boss of mine started a photo library from his living room with a shoebox of transparencies and recently sold

the business to one of the larger photo libraries for a considerable sum. For many starting out in the photography industry, bootstrapping is an option.

Aside from alternative income from what is preferably a photography-related field, the best form of funding is savings or borrowing from family or friends (unless they charge you interest). The other option is to borrow from the bank or credit cards. If you go this route, shop around for the best deal and don't be lulled into the false sense of security that it's free money. Borrowing money is simply buying time, but it is often a necessary evil.

Planning ahead

It is an unavoidable fact that the most common reason for businesses failing is lack of financial planning and lack of cash flow. Regardless of how good a photographer you are, if you haven't got sufficient funds to operate, your business won't last long. Look ahead into the future, at least the next three years, and plan how you are going to manage financially.

Dealing with figures and managing finance doesn't always go hand in hand with being creative and, let's face it, the thought of spending hours working out profit and loss, balance sheets and cash flow is soporific to most. There are however just three basic areas to consider:

- What amount you need to survive on
- How much your business will cost to run
- How much income you will have coming in

Business structure

One of the things you need to decide when setting up your business is what structure or entity your business will be. This determines your legal status and how you pay your taxes. There are several options, but I've found that the first option works well for most photographers.

Sole trader

The simplest form of trading. A sole trader consists of one person trading, also known as being self-employed. Even though you may have several members of staff, you are ultimately and solely responsible for your business. One of the disadvantages of being a sole trader is that you are personally liable for all your business debts.

Some people think that you are not a proper business if you're not a limited company and therefore don't have a company registration number. Not true! A business is anyone who trades.

Partnership

This is two or more people trading together, based on the same principles as a sole trader. Essentially you are all individual sole traders with the same tax issues. It's different in Scotland, but in the UK everyone in the partnership is jointly and severally liable. This suits some photographers who prefer to work in a team, but make sure you've set out mutually agreeable terms in writing so everyone's clear.

Limited liability partnership

Has the same tax advantages of a sole trader and limited liability.

Limited company

The term 'limited' in this context refers to the fact that you have limited liability for debts. Sounds too good to be true? It's not that simple. For a start it requires a lot more paperwork than the above options, and you need to register your business with Companies House (www.companieshouse.gov. uk). The company needs to consist of a company secretary and at least one director (these need to be different people) and more paperwork needs to be taken care of if these change. You need to file annual accounts, and failure to do so will result in a fine. You also need to comply with certain standards.

Tax, VAT and National Insurance

When you become self-employed, you need to notify HM Revenue and Customs as you will be responsible for paying certain taxes. You can go to jail for fraud if you don't.

Income tax

If you are a sole trader you will be required to pay income tax on the money you earn. This includes any money you are paying yourself.

Corporation tax

If you are a limited company, you will be required to pay corporation tax on your profits.

National Insurance

You will have to pay your own National Insurance contributions. If you have full-time employees you will be responsible for paying their National Insurance on top of their wages.

VAT

You need to register for Value Added Tax when your turnover is over a certain

threshold. This threshold changes, so check with your local revenue office. In addition to reporting all your income, you can also take every deduction to which you are legally entitled. Your VAT payments are made each quarter. All you need to know on this subject can also be found on the website of HM Revenue and Customs (www.hmrc.gov.uk).

Professional financial services

When your business is up and running, you'll need to enlist the help of some financial professionals. You will need the following:

A bank manager

It's likely that you'll already have a bank, but it is advisable to keep your business banking separate so as not to confuse personal finances with business ones. Also, sticking to a bank you know has its advantages in that you have a track record, but it's good to look around to see what others have to offer. You'll need a business current account, a higher interest savings account and a business credit card.

When you open a business bank account you are assigned a business manager or a 'relationship manager', as mine is called. These people can advise you on all sorts of issues with regards to your finances and usually offer a helpful start-up pack.

An accountant

I asked Stephen Poole, my accountant, to summarise what accountants do and why you need one. Here was his response:

> ‘Good grief! There are shelves of books on accountancy – the subject covers so much ground that it's hard to know where to begin. A bit of further reading is in order if you are hungry to know more, but here is a list of the main things that accountants can do and the benefits of having one.’

An accountant can:

- Help you decide what type of trading 'entity' and ownership structure to have when you first get started.

- **Design and set up your accounting systems so that year-end financial reporting will be easier.**

- Ensure that you pay the correct amounts of the correct types of taxes at the correct times.

- **Ensure that you complete and return the proper forms to the proper authorities at the proper times.**

- Advise you on expense deductions and how to separate your personal and business expenses.

- Advise and guide you through an audit or enquiry, such as an Inland Revenue or VAT enquiry, if you ever have one.

- Advise you on specific transactions, such as whether it's better to lease or buy equipment.

- Compile your financial statements each year, in whichever form your chosen business entity requires.

- Analyse and help you understand the figures shown in your financial statements.

- Advise you on what kinds of business expenses are allowable and tax deductible. Many of these rules and regulations change with each new Government budget.

- It is also important to ask your accountant's advice before you take action. It's almost always easier (and cheaper) to structure things properly up front, as opposed to trying to fix something later.

STEPHEN POOLE, ACCOUNTANT

A book-keeper

You need to 'do your books' for the following reasons:

O To show the financial performance of the business over a monthly or annual period, that is, to find out whether you are making or losing money.

O To provide information to the Inland Revenue for taxation purposes.

O To keep a record of everything you buy (purchase ledger) and everything you sell (sales ledger). Reconciling this tells you your profit and loss.

O To see what invoices are due and need to be chased for payment.

You can do this yourself – there are several book-keeping software packages available – but it is false economy to spend days struggling with something you are not used to or at which you are not very good when you can hire an expert to do it in much less time: you can employ a book-keeper for however many days a month you need them for instead. I chose the latter route as soon as I set up my business and have a fantastic book-keeper. I really should give her a grander title, such as Head of Finance, as she often goes beyond the call of duty and is a font of information on all money matters. To the outside world she is known as the 'accounts department'.

My book-keeper's advice is 'File everything'. Keep separate, labelled files, in chronological or alphabetical order: one file for purchase invoices, one for sales invoices, one for receipts, one for bank statements, one for credit cards

statements and so on. We start new files each financial year, using a new colour to make it a bit more exciting.

Apart from keeping records of your accounts, book-keepers are very handy when it comes to chasing unpaid invoices. Although you will mostly be chasing the accounts department for money and not the person whom you worked with directly, it's not the nicest job, but someone's got to do it.

I found both my book-keeper and accountant through personal recommendation. It also really helped that they had other clients in similar areas, so understood my business.

Premises

The good thing about being a photographer is that you are unlikely to need large premises. It used to be the case that a lot of photographers bought or leased photographic studios, which they used for shoots and as an office. When the recession(s) hit, many of them could no longer afford this large and often unnecessary overhead, or they had to rely on hiring the space out. Photographers often find that different shoots warrant studios of different sizes with different facilities anyway, so unless you are shooting most days of the week in the same size studio, it can be just as easy to hire as needed. There may come a day when it is more cost effective for you to have your own studio, as opposed to renting one each time, but until then, it's not advisable.

When you're not shooting or out networking and promoting yourself, you can usually do the rest from a desk at home. As photography can be a solitary business, some photographers prefer to rent affordable desk space with like-minded people.

Staff

As with premises, when you are first starting out as a photographer it's unlikely you need to take on any permanent staff. You can hire an assistant or a producer on a project-by-project basis when you need them. When you are busy and successful, you may want to consider taking on some of the following staff:

- Assistant
- Studio manager, if you are studio-based
- PA
- In-house PR/publicity manager
- In-house producer
- In-house agent, as opposed to a photographers' agent in the traditional sense (see Chapter 8 for more on agents)
- Book-keeper

Generally business supplier terms should be fairly straightforward but make sure that you are comfortable with the contracts of any photographic service suppliers you hire in, such as model agencies, location libraries or stylists. Pay particular attention to copyright and usage of images, cancellation fees, how many hours constitute a 'working day', overtime, payment terms and also insurance requirements.

Further advice on business and financial management can be found on these websites:

- www.businesslink.gov.uk
- www.startups.co.uk
- www.freelanceuk.com
- www.newbusiness.co.uk

'How did I get started and grow my business? A mixture of careful business planning, shrewd marketing, and a fun, quirky style helped to set me apart from everyone else.'

JULIA BOGGIO. © JULIA BOGGIO
WWW.JULIABOGGIOSTUDIOS.COM

7 Marketing and promotion

To recap: you've gained the necessary knowledge, training and experience. You've decided on your niche. You've researched and identified a market for your photography. You've built up a body of work. You understand the basics of running a business. As in any type of business, if your product is ready – it's time to go to market.

It's important to be as consistently proactive with your marketing as you are with your photography. The amount of time, effort and money you invest in this area will be directly correlative to the amount of work you get. A lot of photographers don't enjoy the prospect of selling themselves, thinking it involves a lot of cold calling and rejection. Some of them even think this is the sole purpose of agents, but more of that in the next chapter. Yes, successful marketing requires focus and commitment, but it certainly pays off. It's very rare to find a photographer who seems to go from job to job with little or no marketing, and out of all the photographers I've represented over the years, it's certainly the ones with an enthusiasm for selling their work and themselves who have reaped the rewards and been the busiest.

'Which marketing methods are most effective?' is a question I regularly get asked by photographers, along with 'Which listing brings in the most work?', 'Is it worth entering the so-and-so awards?' and 'Is there any point in tweeting?'. Things aren't that black and white when it comes to marketing most photography. The key is to use as many portals as you can so you are as omnipresent as possible. An article in the press could be as instrumental to getting a job as having a high search engine ranking.

There will never be a definitive list of ways to market yourself as a photographer, and in this evolving world of technology new opportunities arise all the time, but here are a few ideas to get you started.

Create a brand

Getting your image (pardon the pun) right is important in any industry but especially so in such a visually aware one as photography. The most important thing to do first is to create a brand identity for your business. Successful brands are memorable, visible, consistent, reputable, alive and

instill confidence in the consumer – they don't let you down. How do you incorporate these qualities into your own brand?

Step 1

Work out what you're going to be called and register a domain name.
Keep it simple and relevant: choose a straightforward domain name, such as yournamephotography.co.uk or something that really 'does what it says on the tin'. This will then be used as your email address. You need to project an appropriate image – a funny nickname you had at school is not a good idea.

Step 2

Employ a good graphic designer to design your brand identity.
At its most basic, your brand identity will include a font and a particular brand colour or selection of colours. Unless you really are a talented graphic designer, I would not recommend trying this yourself. Avoid anything too clever; you'll soon tire of it as will everyone else. The design should somehow match and complement your photography. Failing offers from the award-winning design agency of your dreams, how about asking a graphic design student?

Step 3

Use your branding consistently throughout all your marketing tools and business correspondence, from your website to your email signature.

Step 4

Become visible by utilising some or all of the marketing ideas listed below in an effective marketing plan.

Step 5

Don't let all your hard work go to waste when clients deal with you, 'the person behind the brand'.

The way you present yourself and provide your service are integral to the brand. More than once (albeit not with my current stable of photographers!), I have enticed potential clients with the right marketing tools, lined up a meeting and it's all gone out the window at the face-to-face meeting. I've had photographers sit there mute, offering up nothing, and ones that left half-way through a meeting as their parking meter had run out, never to return.

Consistently demonstrate competence, enthusiasm and professionalism in all areas, from the message on your answering machine to how quickly you respond to a request for a costing.

Twenty marketing ideas

1) HAVE THE BEST WEBSITE OR ONLINE PRESENCE POSSIBLE

And by this I don't mean the most expensive or the most fancy. Other marketing tools will grab people's attention, but the automatic default for a client who wants to know more about a photographer is to visit his or her website. Some photographers have replaced their website with a blog (see below). As long as your work is presented in a useful way, this approach is fine.

Your website should be:

- Quick to load
- Well designed
- Easy to navigate
- Well edited
- Divided into user-friendly categories
- Informative
- Regularly updated

2) MAKE THE MOST OF SEARCH ENGINE OPTIMISATION (SEO)

Search Engine Optimisation is a process that enables your website to rank higher in searches on the major search engines. 'Googling it' seems to be the knee-jerk reaction these days when we are looking for most things, and the same applies to photography. If a potential customer types words relating to the product you can offer into a search engine, you want to make sure your website comes high up the ranking, as people rarely get past the first page of search results. To achieve this you need to include as many relevant key words as you can on your website. This is called keywording. Your website designer should be able to give you further advice on this, and there are specialist companies that offer a SEO service (a useful place to start is www.seomoz.org). Photoshelter, a US-based company offering website solutions to photographers, has also prepared a comprehensive guide on the subject of SEO, which is downloadable from their website (www.photoshelter.com).

3) PREPARE THE BEST PORTFOLIO YOU CAN

A printed portfolio

When I use the term portfolio, I am referring to a hard-copy portfolio containing prints, just like its literal translation from the French *porte folio* meaning 'page carrier'.

Sometimes also known as a 'book' or 'folio', it's a smart folder with an edit of your best and most up-to-date photography. The purpose of a portfolio is to present your images in a practical and commercial way to potential clients in order to encourage them to give you work.

I sometimes get asked, 'Doesn't everyone just look online these days? Do I really still need a printed portfolio?' The answer is a resolute yes. As long as there are face-to-face meetings, as long as there are printed end applications (magazines, brochures, posters, prints), the portfolio will still have a place. There will be times when a client commissions a photographer simply from viewing his or her work on the website. But generally speaking, I think the portfolio will be with us for a few more years.

The majority of advertising and design agencies, and most magazines and newspapers, still 'call in' portfolios: that is, they ask for portfolios to be couriered to them when considering photographers for commissions. It is assumed that you will bring your portfolio along to any meetings. If your market is consumer or private clients – weddings, family or pet portraits, for example – it's preferable to present your work in a folio initially rather than on a laptop, as the end use is likely to be framed prints. Aside from anything else, looking at prints is a welcome break from the glowing screen.

Whichever industry you are aiming to get work from, the presentation of your portfolio should be of a high standard. Whether it's eye-catching and slick or scruffy and out of date, presentation says a lot about the photographer and the service he or she is likely to deliver. As with all your marketing efforts, you need to give the impression that you're a professional and that you mean business.

Here's some further advice on how to get the most impact out of your portfolio:

O Get the best portfolio and slipcase you can afford. Avoid anything that looks cheap or 'studenty', like a spiral-bound or small document folio.

O Avoid a bound book, as it's important to update the folio regularly. It's also good to have the option of tailoring your portfolio to suit particular clients' needs.

O Have your name embossed on the cover and the slipcase in the font of your brand identity.

O A folio with a pocket in which to put your cards is handy, so they don't end up crumpled.

O In terms of colour, black is fine, but if you want to stand out from 99% of the photography population, try something different. Don't get overly creative – a tiger print fake-fur cover is only appropriate if your work is very flamboyant.

O Avoid a box of loose prints. Prints might get lost, and having to worry about putting the prints back in the right order can be off-putting.

Besides, you can use the juxtaposition of images in an album-style folio to your advantage.

○ Make sure the prints are good quality on decent paper. Hahnemühle fine art inkjet paper is very nice, for example.

○ Avoid acetate sleeves as they are reflective and can easily get scratched, making it difficult to see the images.

○ As for size, A3 or A3 plus is good. Your portfolio shouldn't be so cumbersome as to become unmanageable. To avoid hefty courier bills, it should fit on a bike.

○ Have a page with all the necessary contact details at the beginning or end of the portfolio, plus a tag on the slipcase to identify its owner and double up as an address label.

○ Present the images in landscape or portrait format according to which best suits your work. Don't mix them up; it's not practical to have to keep turning the book around.

○ Between 30 and 50 images is an acceptable number. If you include some pages featuring multiple images, you can get away with showing more overall. This approach can be appealing to design agencies and magazines, who are used to looking at photographs as stories rather than singular images.

○ Include some thumbnails at the back with captions. It puts your work into context for the client.

○ A list of recent clients will give a potential commissioner confidence.

Some of the following portfolio suppliers can offer a full package and further advice:
- www.cathyrobert.com
- www.wyvernbindery.com

JULIAN CALVERLEY'S IPAD FOLIO WWW.JULIANCALVERELY.COM/WWW.FOLIOBOOK.MOBI

- www.silverprint.co.uk
- www.plasticsandwich.co.uk
- www.brodiesfolios.com

A digital portfolio

Although the printed portfolio might show off your images to the best advantage, sometimes it's more appropriate to present your images digitally. Perhaps you are travelling overseas to show your work, presenting to a digital agency or having a meeting about your images being used in an online magazine. When presented well, an electronic form of your portfolio on a laptop or the current flavour of the month, the Apple iPad, can certainly be impressive. This form of presentation also enables you to show additional images and video if you need to.

There are several photography portfolio apps available that allow you to customise your presentation – Folio Book (www.foliobook.mobi) has been highly recommended and the photography blogs and magazines regularly list new ones. To complete the package, consider having a slipcase customised with your branding for your iPad or laptop.

4) DO SOME 'GO SEES'

By this I mean make some appointments to show your portfolio. Either buy prepared databases of commissioners of photography (such as those found at www.bikinilists.com or www.filefx.co.uk) or compose your own and start cold calling (see Chapter 2 for information on who buys photography and which person to speak to). Set yourself a target of appointments to make per month. Don't be put off by the fact that you might need to make 10 calls before you get to speak to someone, and then the next slot in the diary is in six months' time; it happens to the best of us. If you can't speak to someone on the phone, there's not a lot of point in leaving a message: instead send an email with a link to your website, explaining why you'd like an appointment.

When you show your folio, try to make it a relaxed, enjoyable experience for you and the viewer. Don't take up too much of their time, half an hour

at the most, and don't feel you need to talk about every image. People like to talk about themselves, so do your homework before your meeting so you can ask the person you are seeing relevant questions, too. If the meeting goes well you often find people might recommend other contacts for you to see. Send another email or a handwritten note after the meeting thanking them for their time. You should only attempt to go back and see the same person again if you have new work to show.

> 'Making appointments to see picture editors and art buyers can be a daunting process as they are usually very busy and hard to pin down. Getting the all-important telephone numbers or email addresses can be a battle on its own, so using resources such as Bikini Lists (www.bikinilists.com) is a great start. Once you have worked out who will respond best to your work, you need to dedicate time to sit down and make the calls. It may take ten or more calls to get one appointment, so it is important to be persistent. However, avoid leaving voicemails where you can or sending lots of emails, as you don't want to make them feel harassed!
>
> If you do manage to get a foot in the door, you need to be prepared to present your work with confidence. You also need to turn up with quite different portfolios with a balance of personal and assigned work. Newspaper or magazine picture editors are generally more interested in your self-contained picture essays or your ability to handle high- pressure assignments. In contrast, art buyers will usually focus on your photographic style, and whether you can respond creatively and professionally to their briefs.'
>
> THOMAS BALL

5) SEND OUT SOME PRINTED MAILERS

As with the printed portfolio, the jury is out on the future of printed cards. The direct mailshot used to be the main promotional event for a photographer, but it's becoming a lot less prevalent with so many online opportunities these days and the obvious environmental issues. I even heard a rumour recently that one well-known advertising agency refuses to pass on photographers' cards to the art directors. For now though, I still think it's worthwhile doing a small and targeted mail shot once a year.

6) GET A SMALL PRINT RUN OF BUSINESS CARDS

Business cards are a useful thing to give out at meetings and when networking. I find that most formal meetings with clients about a commission still start with cards being handed out.

7) GET LISTED

Directories, handbooks (online and printed) and associations often offer free listings. Research the best ones for your market and which your competitors use.

An example of an LPA emailer, keeping everyone updated on the latest news. Images © Michael Heffernan.

8) Send direct email

The 'e-mailer' is the replacement for the traditional printed and posted direct mailshot. Either buy ready prepared databases of commissioners of photography (such as those found at www.bikinilists.com or www.filefx.co.uk) or compose your own, then email updates to potential and existing clients on a regular basis. Be respectful of people's time and realistic about what they will be interested in looking at.

9) Blog

An online journal that also allows for interaction with others, a blog can be a very useful and effective marketing tool. Blogs are relatively quick, inexpensive and simple to set up (for example at sites such as www. wordpress.com), easy to update with your latest news and images, and a fun way to engage and interact with others in the industry. It is usual to integrate your blog into your website, but I know of photographers who have a blog instead of a website. As with all social media, blogging boosts your Search Engine Optimisation (see p.74).

10) Twitter and other social media

Every time you post something interesting on your blog you can alert the rest of your online community via portals such as Twitter, Facebook, LinkedIn and any photography forums you have joined. One of the benefits of online socialising is the speed at which you can make contacts: make sure you exploit this by adding them to your database.

11) PLACE AN AD

I have heard it said a few times that advertising doesn't work. As a stand-alone marketing method, it can be expensive and unlikely to give you a return on your investment. However, as part of a marketing plan, a strategically placed advertisement – to accompany an article in a trade magazine, for example, or a banner ad on a photography blog – can be effective.

12) BOOK A STAND AT A TRADE SHOW

Trade shows can be expensive, so look for a good deal. This type of promotion is particularly good for consumer photography – at a wedding show, for example.

13) EXHIBIT

An exhibition of your work is a good way to raise your profile. It's a great excuse to host a private view too. If you find the prospect daunting, consider a collaboration with other artists. An exhibition could simply involve preparing 10 prints, finding a free venue (such as a room in a pub, in return for bringing in custom), sending 100 emails to invite people and then lots of free PR. Look into the possibility of sponsorship deals with printers and venues.

14) PUBLISH A BOOK

These days, there are two options to getting a book published: the traditional route via a publishing company (such as this book) or self-publishing. Thanks to companies such as www.blurb.com, www.lulu.com and www.ubyubooks. com, publishing your own photography book is now within your grasp.

These companies offer online print-on-demand publishing facilities. Self-published books are perfect and impressive for a small, targeted mailshot. You might even be able to sell them.

15) Enter competitions
Everyone wants to work with an award-winning photographer – if they've won an award, they've been given a stamp of approval. Enter as many competitions as you can. Awards and competitions are listed in the photography magazines.

16) Get some press attention
This option is often overlooked. There are many ways to get your name in print or on the trade blogs for free: if you have anything newsworthy to show off about, send some information about it to the trade press. It's the job of the editors and reporters to write about anything of note, so you will be helping them. Once seen in the press, your first commission for a design agency might open the floodgates to many more.

17) Network
You can't beat good old-fashioned face-to-face networking. Go to events and private views and mingle. Even if you don't get an introduction to your dream client, it's a good way to catch up with like-minded people, share some stories and information.

18) Talk
A talk (as in a presentation) is an effective way of holding the attention of several people for a reasonable amount of time. It's also not the scary prospect you might think it to be, as often you are simply providing a narrative to your images. Consider presenting a particularly interesting project to an agency or a magazine, or look into seminar programmes. You will also benefit from the associated publicity if the talks are advertised.

19) Send a gift
But don't send any old tat. A print of a favourite image, a self-published book or a tasteful present at Christmas are fine, a naff pen with your website address is not. Having said that, I still use a wine cooler with the logo of a model agency on it five years after it was sent to me.

20) Keep shooting!
It's crucial to refresh the images on all your marketing efforts on a regular basis. An art buyer at an advertising agency once told me that there's nothing worse than seeing a book that's not been updated for ages: it just gives the impression that the photographer isn't doing anything.

What kind of work wins commissions?

Your portfolio of work defines you, it represents you, it sells you. It's vital that all work seen by potential clients is consistent, both in style and in the way it is presented.

In my experience photographers are not always the best judges of their own work and find it difficult to be subjective; too many emotional connections seem to cloud their judgement. An image that may well inspire a commission might be excluded because the photographer has tired of it or associates it with a negative experience. Get a second opinion from a peer or preferably an industry expert. Here are some tips on editing your work for promotion.

O *Be selective and only show your best work*
 If you find yourself being indecisive over any particular image, ask yourself this question: if you could only choose one image for a mailshot, would this one be good enough or representational enough of your work? If the answer is no, don't include it.

O *Only include work that will be relevant to the viewer*
 There's not usually much point in showing gritty photojournalism to a design agency, or corporate photography to a fashion magazine.

O *Do include a broad range of subject matters within your niche*
 An architectural photographer might include interiors and exteriors; a portrait photographer might show a variety of ages, sexes and global ethnicities.

O *But don't repeat yourself unnecessarily*
 You don't need multiple shots of roads at night or too many images with white backgrounds, for example.

O *Pay attention to juxtaposition and flow*
 Position images so they work for and complement each other. Your portfolio should have a beginning, a middle and an end. First impressions count, and clients will want to categorise you from the first few images they see.

O *Leave a clear and memorable impression*
 You can achieve this with a confident signature style and/or cohesive subject matter. At the very least your portfolio needs to look like it's all by the same photographer.

O *Show photographs from a genre in which you want to get more work*

It's rare for a library to buy images outright to add to their stock; they usually ask a photographer to submit images which they then either reject or accept. Image entry requirements can be found on the library websites and will as a rule include a certain standard file size and format, details of clearances required (that is to say, all necessary model and property releases) and other business terms, such as the percentage of sales retained by the library. If and when they sell usage licences for these images, the photographer will receive payment or royalties.

Some libraries do require creative stock shot to a brief and still pay for photographers to shoot images, but in this case it is likely that the library will require the photographer to assign copyright of the images, thereby relinquishing any future usage fees.

Images are licensed in two ways: rights-managed and royalty-free. Rights-managed images are priced according to the specifics of usage (size of image, print run, distribution). The benefit to the buyer of using rights-managed imagery is that he or she can safeguard against the images being used by a competitor if exclusive usage is bought.

Royalty-free images are not priced according to usage but simply file size. Having said that, usage is restricted by virtue of the file size being small, for example. For a relatively low fee the buyer can use the image multiple times; they cannot however authorise others to use it. As there is no restriction on usage and the costs are low, it is more likely for royalty-free images to be used many times and associated with many products and services. Royalty-free images can sometimes be distinguished by their low production values and simplistic concepts.

Zoe Whishaw is a commercial photography consultant providing creative direction, strategic advice and mentoring services for photographers, photo agencies and businesses. Zoe's previous role was as European director of photography at Getty Images, where she worked for 17 years. (www.zoewhishaw.com)

'Stock photography is a multi-million dollar business; there is a huge need for pre-shot content. Why not supply it? The higher end creative stock is used by advertising agencies and clients with bigger budgets, but there are plenty of smaller users too, or users who need to change the images they use frequently, for example for a business's newsletter.

A successful creative stock image describes a product or a service in a way that is conceptual and metaphorical rather than literal. It uses humour, emotion or a lateral message. It solves a visual communication conundrum.'

For example an image to be used in an ad for a bank is more likely to illustrate the quality of life or time with your family you might be able to get as a result of being a customer of the bank than it is to be of a shiny new car or coins going into a piggy bank.

'Aside from having the ability to convey multiple metaphors, images that sell also take into consideration things like space for copy. They are not overstyled or understyled, and they are concise, they don't rely on a narrative or prior knowledge. On some library websites you can see which images sell the most as they come up on the first pages.

Pre-shot content can vary from the more functional and obvious to high-end creative, challenging, innovative, award-winning and sophisticated imagery. Shooting stock can be very exciting as you're not pinned down to the specifics of a brief as you are with commissioned photography. It presents a problem-solving opportunity in a visual world.'

It's usually necessary to diversify when shooting stock, for example with commissioned work. There are photographers around who earn a good living simply from stock, shooting thousands of images and employing

An image to be used in an ad for a bank is more likely to illustrate the quality of life or time with your family you might be able to get as a result of being a customer of the bank than it is to be of a shiny new car or coins going into a piggy bank. Family running on beach. © Felix Wirth/corbis

several other photographers, working almost as a production line, but for most shooting stock is likely to form only a part of your photography income. Having said this, it's still crucial to treat shooting stock as a business.

'It's important to get the most out of your shoots and be intelligent about what you are shooting: understand how pictures are used in the world around you, look at magazines, posters, websites. Try and work out why an image is successful. Analyse, deconstruct and be objective about your images. Be excited about photography and aggressive about ways to shoot new ideas.'

Camera Press (www.camerapress.com) is one of Britain's top independent picture agencies. Founded in 1947, it represents high-profile photographers and agencies worldwide and is known for premium celebrity portraits and unparalleled royal collections. Camera Press offers a range of other imagery, including news, travel and features, an impressive historical archive as well as a lifestyle photography department that produces quality shoots and syndicates images and features from a range of international magazines and photographers.

As a syndication agency, Camera Press sells on images that have usually already appeared in print on behalf of photographers, publications and other contributors. Camera Press also has a number of staff photographers and freelancers, mainly in London, New York and LA, who cover events directly, and the company also funds a number of studio shoots of celebrities and actors, using freelance portrait photographers and working in conjunction with publicists.

Jacqui Wald is Editorial Director of Camera Press, she works closely with the photographers and oversees the agency's daily editorial output. She is instrumental in dealing with commissions and copyright issues.

'At Camera Press we cover a wide range of photography, and each discipline covers a different skills set, although a good eye and technical know how are essential for all as a starting point.

For celebrity portraiture, photographers need to be good at networking and oozing with charm to get the best out of often challenging sitters and publicists as well as possessing drive and ambition. Being in the right place at the right time and of course of knowing the right people also helps. The best portraits are those where the personality of the sitter shines through, often revealing more than he or she intended.

For news and reportage the focus is more on grit and determination and the ability to tell a story though your images, and through the images to convey perhaps the horror, danger or sadness of the situation.

For diary, news and events you need to be quick and have strong elbows!!!

Photographers have to edit and wire their selected images in as quickly as possible after the event, so as well as photographers they have to be picture editors and digital desk operators.

Camera Press's top earners are portrait photographers. We work with collections from photographic icons such as Lord Snowdon, Cecil Beaton and Yousuf Karsh, as well as many of today's top studio photographers, including Jason Bell, Perou, John Swannell and Mary McCartney. Studio photographers usually include the celebrity portrait variety, and when I say celebrity I use that term loosely to cover anyone in the limelight, from Hollywood icons to stars of reality TV.

Generally the more prolific a photographer, the more they are likely to earn, but there are certain sets of images that sell time and time again, either because they are so special, or because the sitter in question is rarely photographed. The biggest single sales per session tend to come from exclusive shoots, such as those with a new celebrity baby or celebrity wedding shoots. In terms of pure volume we sell more Sarah Beeny images than we do of any major Hollywood star!

Libraries come in all scales and with different reputations. As for finding the right library or agency for you, the same advice stands as for finding a photographers' agent: if you're work's up to standard, do your research and weigh up which ones are most likely to accept your images. You can usually find the submission procedure plus terms of business on the individual websites.

The British Association of Picture Libraries and Agencies (BAPLA) lists hundreds of libraries and you can search by category on its website to find the appropriate ones (www.bapla.org.uk). Another useful source of advice and information on the business of stock photography is the Stock Artists Alliance (www.stockartistsalliance.org).

Galleries

Galleries can range from high-end fine art dealers to online platforms offering anything from limited prints by contemporary artists to 'wall art' posters. Some high-street retailers (Ikea, for example) also sell contemporary art and photography.

Eyestorm (www.eyestorm.com) is the UK's leading online retailer of contemporary art, offering work by both established and emerging artists. Founded in 1999, the company was initially set up to offer signed contemporary works of art by some of the world's best-known artists and photographers at prices many buyers could afford. Eyestorm publishes

'For diary, news and events you need to be quick and have strong elbows!!! Photographers have to edit and wire their selected images in as quickly as possible after the event.'

JACQUI WALD, EDITORIAL DIRECTOR OF CAMERA PRESS.

PRINCE WILLIAM AND HIS NEW BRIDE CATHERINE KISS ON THE BALCONY OF BUCKINGHAM PALACE.

© TRISTAN GREGORY/CAMERA PRESS LONDON

with artists such as Damien Hirst, Helmut Newton, Jeff Koons and Richard Billingham, plus many more.

Angie Davey is the creative director at Eyestorm. Previously, she was head of artist liaison at the company, and has been involved in selecting works for the gallery for the past 10 years.

'In my opinion, fine art is something visual that can be appreciated on many different levels, generates a reaction and gives a message of some kind. When I'm looking to take an artist's work on to sell as part of the Eyestorm portfolio, I look for something that works aesthetically but also has an interesting concept and "reason". I wouldn't necessarily recognise a drawing of a cat on a windowsill next to a bunch

of flowers at "fine art" unless it was giving another message of some kind, other than just a straight representation.

Artists are generally found by going to exhibitions, degree shows, art fairs and by approaching those we want to work with. Depending on how established they are in their career, we will either offer to publish with them or show their originals.

As we are a commercial gallery, a large part of the selection process depends on whether or not we think work is going to sell. It's difficult to know what sells, but it tends to be the works that are reasonably priced and aesthetically pleasing, or works by a well-known artist that clients may buy for investment. Very large works can be unpopular as these are difficult to fit into someone's home, and works with shocking imagery can also be difficult. Colour can also play a part – anything too fluorescent could be difficult to sell.

It's extremely difficult to make a living from being a fine art photographer, which is essentially the same as being an artist. You need to be very motivated and proactive about making and then trying to sell your work. There are many online galleries that exhibit and sell photography, so approach the best ones first. There are also online platforms for artists, such as Saatchi Online (www.saatchionline.com), where artists can exhibit their work independently, although with these you wouldn't necessarily have a gallery promoting and selling your work for you. It's more just a reference page for you to exhibit images.

To be successful in being accepted by a gallery, you need to make sure your work is strong. When looking for new artists and photographers for Eyestorm, I look for quality, consistency and uniqueness – something I've never seen before always stands out. You must make sure that each piece of your work is of gallery quality and good enough for someone to buy and hang on their wall. Your work should be signed, and normally photography is sold in limited editions. Galleries can give advice on publishing your works, but try and think as professionally as possible. In terms of content, your subject matter should be consistent – a strong series of works is essential when applying to galleries. Nobody wants to see a mish-mash of individual images with no connection to each other.'

9 Pricing photography

Everyone knows roughly how much a loaf of bread costs or the going daily rate for a plasterer or a plumber, but putting a price on your photography is not as straightforward. Photographers often feel out of their comfort zone discussing the value of their work. They are usually anxious that they might overprice or underprice themselves – there is no book of rates to refer to and clients aren't always upfront about budget. There are several elements to consider when quoting for photography, the most important one being *how* the image is used.

The photographer should always retain ownership of his or her photography, also known as retaining copyright. Whether selling existing work or commissioned photography, never sell outright ownership of the images: instead grant a temporary licence, also known as a usage licence or licence fee. The more usage is required and the more commercial exposure an image might have, the higher the price.

Copyright

Copyright is part of a group of rights known as intellectual property rights (IP) – intellectual as it's a product of the human mind, and property referring to something that can be owned. To own the copyright means you own the right to copy or authorise others to copy the image. According to the Copyright, Designs and Patents Act 1988, which protects literary, dramatic, musical and artistic works, a photographer owns the copyright of his or her image as soon as it is created. You don't have to register your copyright and it lasts for the creator's lifetime, plus 70 years.

Copyright is a much misunderstood term. You are likely to come up against clients insisting that they require your copyright, but in the majority of cases this is not actually what they want, or need. A client is usually motivated to ask for copyright either because they paid for a shoot and would like to use the images freely without having to ask for permission, or they want exclusive use to prevent the images being sold to and used by others.

Whatever the client's motivation, you don't need to assign them your copyright: you simply need to grant them a usage licence that will meet

their needs. When clients understand the concept of copyright and that the extent of the usage is reflected in the price, they quite often realise that the usage they require is nowhere near the scale of a full exclusive buyout.

Five reasons why you should never assign copyright

1) Copyright protects the moral rights of the creator. If you assign copyright, you will relinquish control of where and how your photography is used. This might result in the images being used in association with something you are strongly against. For example, your picture of a fox could be used for a pro-hunting campaign.

2) You expose yourself to liability. If, for example, your image of an Asian man is used to promote a political party with a racist manifesto, the subject of the photograph could seek legal proceedings against you.

3) Copyright protects the economic rights of the creator. If you sign over your copyright, the assignee can resell your image to third parties and benefit financially.

4) The image can be altered or digitally manipulated by others but still be assumed to be your creation, thereby tarnishing your reputation and integrity as a photographer.

5) A usage licence granting exclusive, all media, worldwide, in perpetuity rights fulfils the same needs to the buyer (unless they do intend to sell the image on) while allowing the photographer to retain copyright and full control of where the work is reproduced.

FURTHER READING ON COPYRIGHT:
The ABCD of UK Photographic Copyright: A Guide to the 1988 Copyright Designs and Patents Act for Photographers and Commissioners can be down-loaded from a website set up as a resource for editorial photographers in the United Kingdom and Ireland (www.epuk.org). A PDF called *Copyright 4 Clients* can also be downloaded from the Association of Photographers' website (www.the-aop.org).

Usage licences

As explained above, when we sell photography we grant a temporary usage licence for which the buyer pays a licence fee. Usage licences permit the buyer to reproduce the photography in a specific and restricted way, and for a cost that reflects the extent of the usage.

How much do you think this shot is worth?

IT IS IMPOSSIBLE TO TELL HOW MUCH
A SHOT IS WORTH JUST BY LOOKING
AT IT.

NICK DALY. ROBOT.
© NICK DALY
WWW.NICKDALY.CO.UK

It's actually impossible to say how much an image is worth just by looking at it. The answer is entirely dependent on how the image is used – on what, where and for how long. When we understand what the photography will be used for, we can understand how the buyer will benefit or profit from it. The extent to which they are likely to profit indicates how much we should charge. The more commercial exposure an image gets, the more expensive it should be: the photography on a worldwide poster campaign for the latest mobile phone has a larger potential return on investment (ROI) than an image used to illustrate an article in a magazine or a wedding picture that will be on display in someone's home.

Granting a usage licence is not a complicated legal process: you simply need to agree a fee to cover this usage in writing, usually in the form of an estimate to start with, and then once this has been accepted, send an invoice stating clearly the usage licence granted. This documentation will provide proof of the usage granted to the buyer and the photographer.

Once the usage licence has expired, the buyer should no longer use the image unless an additional usage fee is paid. If they are still using the image without agreeing to and paying this fee, they will be in breach of copyright.

The photography markets

To quantify the usage we first need to establish which market the photography will be used in: this will give us a good indication of the purpose for using photography and therefore its value to the buyer.

Photography market	Reason for using photography	Examples
Commercial	To promote or endorse a product or a service	An image of a dog on a tin of dog food
Editorial	To illustrate a newsworthy story or something of public interest	An image of Prince William and Kate Middleton on the front page of a newspaper
Consumer	Aesthetic or personal appreciation, investment	A wedding album or a print hanging on a wall

THE COMMERCIAL MARKET

As the purpose of photography for the commercial market is to promote or endorse a product or a service, commercial photography is always associated with a trading business or corporation. Commercial usage can be anything from an advertising campaign for a designer perfume to a website for building materials. The perceived return on investment (ROI) for the buyer and therefore the amount a business would expect to allocate from their marketing budgets can vary dramatically.

Factors to consider when quantifying usage in the commercial market:

Factors	Definitions	Examples
Type of business	What size? What type of industry: mainstream or specialist; corporation, education or charity?	Established, start-up, multi-national retailer, local school
Media	The collateral or marketing communication on which the image is reproduced	Billboard, website, leaflet
Territory	Where?	UK, worldwide, regional
Time	How long for?	1 year, in perpetuity
Audience	Who will see the images?	Consumer: the general public Trade/specialist: other businesses in the same industry Recruitment: potential employees Corporate: employees or stakeholders in an annual report or company newsletter

desired fee to calculate the amount of days you need to work at this rate.

a) Business overheads £23,000
b) Personal survival income £25,000
c) Desired fee £1,000

 a) + b) ÷c)

 Minimum amount of days you need to work per year = 48

If you are an editorial photographer, you might work three times as many days as a commercial photographer, in which case the daily rate might be something more in the region of £250–£400.

While I'm not disputing this is a sensible approach, things are not always so cut and dried. At the end of the day Clients will only pay what they will pay, although if you're a skilled salesman and negotiator you may achieve a higher amount than some of your peers. Use the system as a barometer to check you are running a profitable business: if the numbers aren't adding up you might need to look at decreasing your overheads and/or your personal survival income, or consider alternative ways to earn money, preferably something photography-related.

Preparing an estimate

STAGE 1: GATHER THE NECESSARY INFORMATION

Make sure you have everything you need to prepare a comprehensive estimate. Use an estimate template (see p.136) as a prompt to ask your potential client all the relevant questions. A written brief is always the best option so the requirements are clear. Some of the most important things to find out are:

- If it's a commercial shoot, who is the client?
- What shots are required? And how many?
- How will the images be used?
- How long, where and when will the shoot be?
- What will you be required to organise and pay for and what will the client take care of?
- Can the client give you an idea of budget? They may not tell you, but it's worth asking.
- When is the estimate needed by? Try to get specific details, as it's not unusual for a potential client to ask for up to six estimates from other photographers and you don't want your bottom line to be more than all the others as you have made the wrong assumptions. Unless it is a particularly complicated brief, I like to provide an estimate within 24 hours, if not sooner.

STAGE 2: PRESENT A PROFESSIONAL ESTIMATE PACKAGE

Prepare a professional estimate on your letterhead paper. Attach your terms and conditions of business, your VAT registration number and company registration number, if you have these. This will instil confidence in your potential client as well as protecting you contractually.

Send an email with the estimate attached in PDF form, reiterating your interest in the project, affirming the dates you are available and that you have optioned them in your diary. Ask if there's anything else the client requires at this stage, and perhaps attach additional relevant images and mention experience or knowledge that might prove useful.

STAGE 3: FOLLOW UP

Once you've submitted your estimate, I would generally leave it a week or so before giving the client a subtle nudge. An email along the lines of *'Hi Ms/Mr Art Buyer, hope you're well, just wondered if you'd made any decisions on the shoot yet or if there is anything else I can do at this stage?'* is fine. Be interested but don't hassle. Once they know I have submitted an estimate, some of my less experienced photographers have been known to call on a daily basis, asking if there is any news on the job yet. They also insist on trying to find out exactly why they didn't get a particular job, taking it personally and sometimes getting upset. It's disappointing when a client decides to use another photographer, but it's important to retain a professional, helpful attitude throughout the estimating process.

There are many reasons why one photographer gets a job over another, the usual one being that they were the most suitable for the job. A client on a shoot will rarely say they used a particular photographer because they were the cheapest.

If you don't get the job, wish them well with the shoot and add them to your mailing list. If you do get the job – congratulations! Better read the next chapter ...

10 Producing a photoshoot

So your efforts have finally paid off – you've got the job! But what now? It's crucial for your reputation and the success of your business that you are able to follow through and deliver your service smoothly and professionally. Don't make the mistake of thinking that photoshoot production is only about complex shoots with large crews. Whether it's a quick portrait for a local newspaper or an overseas advertising shoot, the same production milestones apply. This chapter takes you through the key production stages and includes some important legal obligations of which you should be aware.

Photoshoot toolkit

On some shoots all that is needed is a photographer and their camera; others require a large production crew, special permits and weeks of preparation. On most commercial and many editorial shoots, a key requirement is an art director. It's not unheard of for the photographer to bring in the art director, but he or she will usually come from the agency or magazine, and will have been involved in preparing the original brief. An art director will act as a director on the day of the shoot, making sure the photographer is shooting all that is required – they might ask the photographer to shoot closer in, or get some extra shots of models interacting, and so on. Without an art director present, there might be room for misinterpretation of the brief and therefore a greater risk that the client will not approve the final images. It is advisable to include a clause in your terms and conditions that protects you against rejection of images, should an art director not be present (see p. 69).

Here is a list of everything you might ever need to consider when producing a photoshoot.

PHOTOGRAPHER Apart from being the person who takes the pictures, the photographer might also be required to be involved in the production of the shoot – the casting, recce or post-production, for example.

CAMERA/DIGITAL EQUIPMENT Most photography is digital these days. There are two main reasons why you should charge for digital production:
 • The high investment involved in buying, running and upgrading digital equipment, software and technology.
 • The time it takes to process the files.

OTHER PHOTOGRAPHY EQUIPMENT/LIGHTING This will depend on the nature of your photography and the shoot. It may be that you need to hire a larger format camera if the end use is a 48-sheet poster, or extra lighting if lighting conditions are bad.

PHOTOGRAPHERS' ASSISTANTS The role of a photography assistant is to do all the tasks required so the photographer is free to concentrate on taking the pictures.

PRODUCER If you feel out of your depth organising a shoot that involves a large crew, models and locations, it's advisable to hire a producer. A producer will know how to plan a production realistically, getting the job done on time and in budget. They will put together the right crew for the right price and take into account any legal requirements.

PRODUCTION ASSISTANT Assists the producer or helps with the production of the shoot.

RUNNER Usually required when there is a large crew. Duties might include meeting and greeting, making tea and coffee, ensuring a location is left tidy, ordering taxis.

RETOUCHER/POST-PRODUCTION Unless this is also your speciality, it might be necessary to work with a retoucher or post-production agency for high-end creative retouching.

STUDIO HIRE Make sure you hire the appropriate studio for the job: do you require daylight or black out? Do you need a cove or a scaffolding rig? What about size, location, access (do you need a drive-in studio, are stairs a problem?), parking and facilities for styling?

BACKGROUNDS Can vary from coloured background papers (coloramas) to ornately painted backdrops.

SET BUILDING Can vary from a mocked-up skirting board and wallpaper to something more elaborate, or even a whole street.

LOCATIONS There are certain laws to take into consideration when shooting on location rather than in a studio (see p.120 for more on legal obligations). If the location is organised by the client, it is up to them to gain any necessary permissions. If you are required to find a location, you can either do this yourself, perhaps by looking in location libraries, or employ a location scout.

CASTING DIRECTOR Sources and books the models, negotiates their fees.

MODELS Any persons appearing in the final images, sometimes referred to as the talent or the cast. Can either be professional models from model and casting agencies or 'street-cast' (this can include children). It is important to agree working hours, other shoot specifics and most importantly usage fees in writing before the shoot. Child models will require performance licences (see below).

EXTRAS Extras can be hired from some model agencies, or you might prefer to street-cast them. Make sure you are clear on the requirements on

the day however, as extras are often required to do as much as the models. Some agencies insist that extras must remain unrecognisable in the final images, so if you think there is a chance this might not be the case, make sure this is agreed with the agency before the shoot.

CHILDREN'S PERFORMANCE LICENCES A performance licence is required in the UK (and many other countries) when a child model is required to work on a shoot.This is to protect the welfare of the child: the system ensures that modelling is not affecting a child's education and that he or she is fit and healthy enough to work. You can apply for the licence from the children's employment officer at the borough council where the child lives (see p. 122).

FIRST AID Some councils insist that a first aider be present on shoots involving children. You can get more information from the Association of First Aiders (www.aofa.org), St. John Ambulance (www.sja.org.uk) or First Aid Cover (www.firstaidcover.co.uk).

STYLIST/PROP BUYER Takes care of all props and wardrobe. Sometimes a separate prop buyer and wardrobe stylist are required, depending on the scale of the shoot, but often this is the same person. Always check the experience of the stylist matches the shoot: don't hire a fashion stylist to source props for a lifestyle shoot, for example.

WARDROBE/PROPS Can vary from supplying accessories to supplementing a model's own clothes to providing several options of outfits. There are several big prop hire companies (see p. 135 for photography services directories) that have massive warehouses full of weird and wonderful props, as well as companies that specialise in anything from stuffed animals to plants.

STYLIST'S ASSISTANT Sometimes required to help with prep for the shoot, or with returns afterwards. If there are several models, an assistant is a good idea so as not to slow the shoot down.

HAIR AND MAKE-UP ARTIST/GROOMER Especially on beauty and fashion shoots, there is sometimes a requirement for two people – one responsible for hair, one for make-up – but on many editorial and commercial shoots, one person takes on both jobs. Again, make sure the experience and skills of the artist match the shoot. Other specialists in this area include manicurist and wig maker.

HAIR/MAKE-UP/GROOMER'S ASSISTANT When help is needed, perhaps on a shoot with many models.

MODEL-MAKING Work with a company that's used to making models for photography, particularly commercial shoots. They understand the requirements, including the (usually tight) deadlines.

ANIMALS If your shoot does involve an animal, hire one from an animal acting agency, where you can find trained animals that are used to the shoot environment.

HOME ECONOMIST OR FOOD STYLIST They make the food and drink used in a shoot look appetising.

FLIGHTS Its usually accepted that a minimum of premium economy is allowed for by clients on anything more than a short flight. Economy seats often have restricted baggage allowance and so any savings made on class of seat are often needed to pay for excess baggage.

ATA CARNETS/FIXER Certain countries require an ATA Carnet, which is an international customs and export-import document. This saves you the hassle of having to complete customs documents at the airport, or having to pay duty or tax on your equipment.

VISA If you are working overseas, you will require a visa for some countries, so do check.

LOCAL GUIDE/INTERPRETER If you think there might be a language barrier or you need someone with local knowledge of the people and territory.

ACCOMMODATION Depending on budget, it's reasonable to expect a quiet comfortable room – at least a three-star hotel, I'd say.

TRANSPORT/LOCATION VEHICLE Depending on your chosen mode of transport, this might include a taxi, mileage or a hire car. If the shoot is outdoors, it might be necessary to hire a location vehicle to carry equipment, for example, or a fully serviced location bus for models to change in and basic catering.

SUBSISTENCE/CATERING Can range from your own refreshments for the day to catering for a large group.

MISCELLANEOUS Insurance, telephone, couriers, and so on.

The best way to source all of the above is to follow recommendations from someone who is experienced and whose opinion you value. This might be someone you know already, or you can ask for advice from fellow members on the photography association forums. Failing that, there are several good photo services resources and directories available in the UK (see p.135). Do still try and get references, however, and check not only that they have experience, but that it's relevant to the job at hand.

A step-by-step guide to producing a photoshoot

Producing a photoshoot isn't just about scouting locations and casting models: logistics such as getting 'sign off' in writing and making sure everyone involved has all the necessary information are equally important, and it helps if you do things in a particular order. This step-by-step guide will take you through the key stages, so you can relax and focus on the photography rather than worry about how it's all going to come together.

STEP 1: SIGN OFF

Assuming you've received the brief and sent over your estimate, the first step to producing a photoshoot is to get cost approval – also known as 'sign off'. Once you have confirmed the requirements of the shoot and what the images will be used for, it is crucial to get your estimate approved in writing before you progress. This will prevent the unfortunate situation of you beginning to organise things, perhaps even turning away other work, only to find that your services aren't required after all. Confirmation of costs in writing is confirmation of the job. If the shoot is cancelled, you will be entitled to invoice for any expenses incurred plus potential cancellation fees (see Chapter 6 for more on terms and conditions).

Larger organisations will usually supply you with a purchase order, a document with a purchase order number that you will be required to include on your final invoice. Purchase orders should include the fee agreed plus the agreed usage of the images, as well as the client's terms of business.

Once the budget has been established it is not generally acceptable to exceed it. If you do, there is no guarantee that these overages will be paid. Although you should include a clause advising to allow for a 10%

contingency budget in your terms and conditions, this should only be used as an emergency fallback. If there are any changes to the brief that do incur costs, these need to be agreed in writing beforehand and the purchase order adjusted accordingly. If the shoot involves anything other than basic photographic expenses, it is acceptable business practice to invoice for and be paid these expenses in advance of the shoot.

STEP 2: CHECK THE SMALL PRINT

By accepting your estimate and commissioning you, the client legally accepts your terms of business. However, be careful to check the client's terms of business, which can usually be found on their purchase order, or they may send you a separate contract. If your client is a member of the public – for example, if you are photographing a wedding or have been commissioned for fine art – ensure they have read and understood your business terms, and know what you will supply and when, and what happens if the shoot is cancelled. See chapter 6 for more on the small print, a fuller explanation of terms of business and what to look out for on client contracts.

STEP 3: PLAN THE SHOOT

Once the shoot has been signed off and the terms of business are mutually acceptable, it is vital that you think ahead and give yourself enough time to get everything ready for the day of the shoot. It's really important to be realistic with timings: don't be afraid to say no if a client asks you for the impossible.

Prepare a schedule for yourself. If the shoot is straightforward the schedule may be very simple:

PRODUCTION PLAN FOR *ALLOTMENT MONTHLY* SHOOT

Client:	*Allotment Monthly* magazine
Description:	Half-day shoot. Portrait of Mrs Green in her allotment
Date of shoot:	12 March 2011
Location:	Wolston, Warwickshire
Notes:	Magazine to arrange logistics and provide details

If the shoot is more complex, you might need to allow yourself up to a month of planning. Send a schedule out to the whole crew and the client to clarify what actions are required. Failure to do this might result in delays.

No. working days	Action photographer	Action client
Day 1	Provide final estimate. Check small print.	Send final brief and shoot details plus purchase order or confirmation of costs in writing
Day 2	Plan journey. Check weather. Check camera and equipment. Check all details and contact numbers received. Send mobile number to magazine and Mrs Green just in case. Call Mrs Green to check she knows what's required and what to wear.	Ensure Mrs Green knows what's required.
Day 3	Shoot.	
Day 4	Deliver edited, colour-corrected images as agreed.	

PRODUCTION PLAN FOR 'HEADS' SHOOT/MINDFULNESS ADVERTISING CAMPAIGN FOR THE MENTAL HEALTH FOUNDATION

The following is an example of a production plan for a shoot my agency organised.

Client:	The Mental Health Foundation
Creative Team/Art Directors:	Will Thacker and Blake Waters
Description:	3 models on location with model-made 'heads' for 48-sheet poster for 'Mindfulness'
Location:	London
Notes:	Photographer/Producer to organise all shoot logistics including locations, models and styling.

As you can see in the production plan overleaf, everything needed to be planned very carefully. First we needed to source the props for the model-making, as the model-making took 10 days. While that was underway, we cast the models and scouted the locations. As soon as the model choices were approved and the stylist knew their sizes and colouring, she could begin the styling and get the appropriate clothing. Once the favourite location was approved, we could apply for a permit. This particular location was in King's Cross, London so we had to apply to Camden Council.

Step 4: Hire and brief the production team

The next step is to hire and brief any necessary crew (this is probably the only step that might not be relevant to all shoots). Crew costs should already have been included in your approved estimate. As soon as you know the shoot dates, check availability and option your preferred team. Confirm details of

No. working days	Action photographer	Action client
Day 1	Provide final estimate. Invoice for expenses in advance.	Provide final written brief. Provide purchase order, process payment of invoice for estimated expenses in advance.
Day 2	Casting, location prep plus prop sourcing for model-making.	
Day 3	Casting, location prep plus prop sourcing for model-making.	
Day 4	Casting, location prep plus prop sourcing for model-making prep.	
Day 5	Live casting, prop sourcing.	Attend live casting.
Day 6	Book models/styling prep/recce locations. Model-making.	Approve models.
Day 7	Styling prep, model-making.	
Day 8	Styling prep/model-making, recce locations.	Approve styling.
Day 9-16	Final Model-making.	Approve locations.
Day 17		Approve model-making.
Day 18	Pre-production meeting.	Pre-production meeting.
Day 19-24	Process location permits /prepare call sheets/arrange transport, catering.	
Day 25	Shoot.	Art director to attend shoot.

THE ORGINAL SCAMP (IDEA) FOR THE MINDFULNESS CAMPAIGN BY WILL THACKER AND AND BLAKE WATERS.

accompany them instead. Some councils also insist on a first aider being present when children are on a shoot.

The CAP Codes

The Committee of Advertising Practice (CAP) produces a set of codes called 'The UK Code of Non-Broadcast Advertising, Sales Promotion and Direct Marketing', known as the CAP Codes for short. Regulated by the Advertising Standards Authority, they are 'designed to protect consumers and create a level playing field for advertisers' and can be found on the CAP website (www. cap.org.uk). Familiarise yourself with the CAP Codes if you are shooting for the commercial market; don't assume your client will be aware of them. They include important information on photographing people, including children, for commercial purposes that relate to alcohol, gambling, tobacco and weight loss, among other things.

Shooting on location

As with photographing people, there are two separate issues here: taking the photos and using the photos.

Shooting in a public place is not usually a problem, unless you are in any way obstructing the public. You'll need to apply for a permit from the local council and also notify the local police if you want to shoot using a tripod, use flash photography or have any crew, for example. The same rules apply to public transport: most railways operators encourage enthusiasts to take pictures, as long as the act itself is not obstructive or unsafe. Prior permission should be sought from the operators if the shoot is commercial, however. Equally, prior permission should be sought from the appropriate authorities if you wish to shoot at an airport.

Some areas that appear to be public places, such as a beach or a National Park, can often be privately owned and permission from the owner must be sought, otherwise you will be trespassing. You can however shoot private property if you are standing in a public place, but you will need to get a property release form signed if the image is to be used commercially.

If you are using a location for a shoot, it is advisable to get a property release form signed (see pp.142 and 143 for useful templates). This is similar to a model release form in that you agree beforehand how and where the images will be used. If you use a location you have sourced from a location library, this paperwork should be taken care of for you.

Shooting overseas

Be aware that the laws affecting photography vary in different countries. Depending on which country you are travelling to, check whether you will need the following:

ATA CARNET Certain countries require an ATA Carnet, which is an international customs and export-import document. This saves you the hassle of having to complete time-consuming customs documents at the airport, or having to pay duty or tax on your equipment. They can be processed within 48 hours and cost a few hundred pounds, but they must be returned otherwise you'll receive a hefty fine.

We always use a company called Dynamic International to take care of our carnet needs. They have a handy list of FAQs on this subject on their website (www.dynamic-intl.com). Some countries require the services of a local 'fixer' in place of a carnet.

VISA Some countries require you to have a work visa if you are planning a shoot overseas. I know a few photographers who thought they'd get away with it but were instructed to turn round and go straight home after some uncomfortable questioning at the airport; one was caught red-handed with the shoot brief and dates in his bag. For more information, check the website of the Foreign and Commonwealth Office (www.fco.gov.uk/en/) and companies specialising in visa services (www.uk.cibt.com or www.globalvisas.com).

Copyright and trademarks

Just as the copyright of a photograph should be retained by the photographer and permission needs to be sought before it is reproduced, you might need to seek permission from the copyright owner when photographing an object that is protected by copyright, particularly for the commercial market. Failure to do so might result in copyright infringement. Works that are protected by copyright include:

- Literary works such as books, newspapers and magazines
- Artistic works such as paintings, sculpture, illustrations and of course photography
- Maps, charts, diagrams
- Advertisements, branding, logos
- Money and stamps. Aside from the Bank of England owning the copyright to bank notes, reproduction in an image can be classed as forgery.
- Buildings and architectural works. Some buildings or structures can be registered as trademarks (the Hollywood sign in Los Angeles, for example), although this is not so common in the UK. It is generally accepted that you can photograph and reproduce an image of a building if it is a public place and you were standing in a public place when you took the picture
- Films, plays, dramatic works
- Jewellery, wallpaper, carpets, toys. Some years ago, a photographer

I represented shot a car advertisement that featured a knitted teddy bear. I had a lady from the Outer Hebrides on the phone soon after the campaign was launched, claiming she owned the copyright to this knitting pattern. She was absolutely right and the advertising agency agreed to pay her a certain sum to settle out of court.

There are some exceptions: in some cases you can use images of copyrighted buildings if this is seen as fair use, that is to say if it won't affect the copyright owner's right to reproduce or otherwise use the work, while in some countries you don't need permission to photograph works of art if they are permanently displayed in a public place. It is also unlikely that you will need permission if the image of the copyrighted work accompanies a news item about said copyrighted work, but it is usual to give the work a credit. In terms of the consumer market, it's unlikely you will infringe copyright laws if the image is just for private display.

TRADEMARKS

A trademark is associated with a certain trading body, for example the Nike 'swoosh', and registered trademarks are protected by the Trade Marks Act 1994. Slightly different to copyright law, trademark law doesn't prevent the reproduction of a trademark in an image but is concerned with the goodwill that might be appropriated and any confusion that might be caused.

If, for example, Mickey Mouse is featured in an advertisement for crisps, the viewer might assume the crisp manufacturer is somehow associated with Disney, and it might encourage them to buy the crisps as they feel the product has the Disney stamp of approval. This could be called trademark infringement.

Insurance

As outlined in Chapter 6, it is a legal requirement to have certain insurance and liability protection. Others are not compulsory, but are recommended because of the financial protection they provide. Have a look back at the chapter to make sure you have all the required insurance.

The law is complex, open to interpretation and is developed as cases evolve. Please seek professional legal advice should you require it – I can only give you a rough guide here, and cannot accept any responsibility for any omissions or errors.

The law also varies of course from country to country – although is often similar – and it is the laws of England and Wales that I am referring to here, unless otherwise stated. Don't forget you need to bear in mind not just which country you took the picture in but also where the image is likely to be published.

11 Tips from the top: professionals' advice for success

See also the section on contributors (pp.132–134) for biographies on many of these photographers and professionals.

NADAV KANDER, PHOTOGRAPHER

'Find your language and your voice and work from this inner dialogue, not from what others are doing. Of course others influence you but let this influence remain just an influence and interpret it to fit your language. With this as your base you can achieve consistency.

In my opinion 'voice' is our personality and depth of feeling mirrored in our photographs and it's this and not stupid techniques that give your work a consistency. Language is the manner in which you express these feelings, reactions and emotions.'

NICK DALY, PHOTOGRAPHER

'My advice is to always reinvent yourself; photographs taken outside of your comfort zone are always more challenging and therefore more interesting.
Our comfort zones encompass language, time of day and geography.'

IAIN CROCKART, PHOTOGRAPHER

'Quite simply, want to and then work at it and never stop working at it.
Practice, study, develop, talk, share, listen, learn, look, look, look and look some more.'

PEROU, PHOTOGRAPHER

'People skills are more important than any other type of skills ... in all aspects of your business.

- Read Dale Carnegie's cringingly titled *How To Win Friends and Influence People*. Also read Paul Arden's books; *It's Not How Good You Are, It's How Good You Want To Be*, and *Whatever You Think, Think The Opposite*.

- Live and breathe photography. It needs to be your passion if you're going to really master the skills and enjoy it at the same time.

(estimate continued)

Item	Description	Quantity	No. Days	Unit Cost	Amount £'s
Groomer's assistant					
Model maker					
Set builder					
Animal hire					
Home economist					
CASTING/MODELS					
Casting director					
Casting studio					
Casting expenses					
Model fees	including usage				
Extras	including usage				
Audition fees					
Chaperone fees					
Childrens performance licence fee(s)					
First aider					
LOCATIONS					
Location scout					
Location scout's expenses					
Location hire/permits					
Location library fees					
TRANSPORT/ACCOMMODATION/SUBSISTENCE/MISCELLANEOUS					
Transport	e.g Mileage, congestion charge, parking, taxis, airport transfers etc. location vehicle				
Flights					
Excess baggage					
Local guide/interpreter					
Carnets/Visa					
Hotel/accommodation					
Subsistence/catering					
Miscellaneous	e.g. Couriers, telephone, insurance etc.				
TOTAL					£

SEE OVERLEAF FOR TERMS AND CONDITIONS OF BUSINESS

< insert your Vat registration number here >

< INSERT YOUR LETTERHEAD HERE >

INVOICE

FAO:

Contact:

Company with full address:

Date:

Invoice No.

Purchase Order Number:

Job Number:

Client:

Photographer:

Art Director:

Shoot dates:

Usage:

Description of shoot:

Item	Description	Quantity	No. Days	Unit Cost	Amount £'s
Photographer's shoot fee	Including the above usage				
Etc., same items as original estimate					
Subtotal					
VAT					
Total					

< INSERT YOUR BANK DETAILS>

See overleaf for terms and conditions

< INSERT YOUR VAT NUMBER IF APPLICABLE>

< INSERT YOUR LETTERHEAD HERE >

PROPERTY RELEASE

This property release agreement is dated _____ and is between _____
("the Photographer") and the undersigned ("Property Owner"), being the legal owner of and/or having the
authority to bind the owner of, or having the right to permit the taking and use of, the photographs of
certain property as below. Agreement as follows:

PROPERTY DETAILS INCLUDING FULL ADDRESS:

DESCRIPTION OF PHOTOSHOOT:

CLIENT/PRODUCT:

AGENCY:

PHOTOGRAPHER:

DATE OF SHOOT:

In consideration of £ _____ received I hereby grant the Photographer plus any licensees or assignees,
the absolute right to take photograph(s) of such property and to use these and any other reproductions
or adaptations from the above mentioned photoshoot, in all forms and media and in all manners, for
advertising, trade, or any other lawful purposes. I waive any right to approve the finished version(s). I
understand that the Photographer owns the copyright of their work and I therefore waive any claims I may
have based on any usage of the photographs.

I also agree that photograph(s) of the property may be used by the Agency and the Photographer for their
own promotional use in the context of the above. I waive any right to approve the finished version(s). I
understand that the Photographer owns the copyright of their work and I therefore waive any claims I may
have based on any usage of the photograph(s.)

Name of Property Owner: (or authorised as above)

Contact details of Property Owner (Address/Telephone/Email)

Signature of Property Owner

Date

*NB: Please note that this form covers images for blanket use; any media,
forever, worldwide, all usages and all products.*

Index